D1578446

IRISH

ART

such a load of shite!

IRISH

ART

1830 - 1990

BRIAN FALLON

APPLETREE PRESS

First published by
The Appletree Press Ltd
19-21 Alfred Street
Belfast BT2 8DL
1994

ISBN 0 86281 438 3

9 8 7 6 5 4 3 2 1

Contents

List of Plates

Black and White

Colour

Introduction

FOR EVEN culturally well-informed people, Irish art got no further than the *Book of Kells* more than a millennium ago. It is something which never happened, a historico-cultural non-event. Irish literature in the past century has gained a world hearing, from Yeats to Seamus Heaney; Irish painting and Irish sculpture are known only to a minority of scholars and *cognoscenti*, museum curators and a handful of salesroom addicts. And even these few rarely have any overall view or "picture" of Irish art and its line of development. Its entire history and pedigree are elements which they have never considered. Their knowledge, as a rule, is piecemeal and arbitrary; they know isolated names, certain individual works, but lack any overall art-historical context in which to fit them.

It is still possible to go through the pages of quite prestigious art encyclopedias without finding an entry for a single Irish artist (I have even found some which ignore Ireland's greatest painter, Jack Yeats). Accepted ideas – which is a polite term for officially approved clichés – take root slowly, but when they do, they root deeply and stubbornly. They derive their strength from the fact that nobody has thought about them much, let alone bothered to question or analyse them, and through this lack of any real debate or weight of intelligent opinion on the subject, they pass from word-of-mouth consensus into something like textbook authority.

As the Bellman says in *The Hunting of the Snark*, "what I tell you three times is true"; and the Irish have been told so often that they have no real tradition of visual art that for the most part they have accepted this without query or looking into the matter. As for other countries, they have scarcely considered the issue at all; for them – Americans and Continentals in particular – Ireland

is the country of James Joyce, Yeats, Beckett and a few other writers with a world reputation. And, of course, the IRA – that and nothing else.

A major chink in this curtain of ignorance and misinformation came with the massive exhibition of Post-Impressionism at Burlington House in London in 1979-80, in which Irish artists – the Yeatses father and son, Osborne, Orpen and Roderic O'Conor – were prominently featured. It showed that Ireland in the early part of the twentieth century had no lack of painters or real quality, even if they could somehow be fitted into the role of British offshoots and tributaries. And even more recently, the renewal of interest in Jack Yeats has gathered considerable momemtum. Yet memories are short, and of the thousands who recently attended the Yeats exhibition at the Whitechapel Gallery in London, how many knew of his inclusion in the Armory Show of 1913 which virtually launched Modernism in America; the retrospective show of his work organised in London in 1948; and the admiration of people as contrasting as Kenneth Clark and Kokoschka – not to mention the award of the Legion of Honour by France? How many people realise the world fame (no exaggeration) of Orpen and Lavery in their lifetimes, or could cite the praise of Danby by Theophile Gautier and of Maclise by Baudelaire? How many Londoners, passing daily by the Victoria and Albert Memorial (admittedly, not one of the highest peaks of nineteenth-century art) know that a central figure in its creation was an Irishman, John Foley? And of the thousands of sightseers, both British and foreign, who file through the Throne Room of the House of Lords, how many realise that its murals are the work of another Irishman, Daniel Maclise?

Nowhere is the prejudice against Ireland's visual arts more entrenched than in literary circles and literary histories, which give full credit to the achievements of the Literary Revival but treat the Irish artists of the period as though they were provincial figures. It has been said, *ad nauseam*, that Ireland produced nothing in the other arts to equal what the writers did; yet anybody with eyes

in his or her head, who has made even a superficial study of the period, will know that virtually the opposite is true. The Literary Revival was the period in which Hone and Osborne, Orpen and Lavery, and a number of very gifted sculptors were active and creative; when Ireland produced a school of stained-glass artists who were possibly the best in the world at that time; the age when John Butler Yeats proved himself probably the finest portrait painter in the English-speaking world; when Jack Yeats, his even more gifted son, began to emerge as an artist of European size. It was, in fact, a golden age in Irish art, and the crafts enjoyed a parallel renaissance.

This was fully realised by many or most of the literary men themselves, as can be proved by the references scattered through the writings of George Moore, Yeats (the poet, not the painter), "AE" (George Russell) and others. The Irish renaissance was never a hothouse, purely literary affair; it embraced all the arts (except, possibly, architecture) and these arts cross-fertilised each other. Neither was Irish painting "literary" – in fact, rather the reverse was true, since the leading writers were mostly steeped in visual culture. This fact is usually overlooked, yet even a superficial study will show that it is an obvious facet of the entire Literary Revival. First of all, there is Yeats himself, son of an excellent painter and brother of another, who even began himself with similar ambitions. The part which painting, from Samuel Palmer and the Pre-Raphaelites to Gustave Moreau, played in forming his imagination needs no underlining to those who know his work and have read any competent biography-study of him. George Moore, too, began with ambitions to succeed as a painter and has chronicled his failure and his conversion to novel-writing both in his *Hail and Farewell* trilogy and in the earlier *Confessions of a Young Man*. At least he had the consolation of becoming a leading art critic, who played a central role in introducing the French Impressionists to England. Edith Somerville, co-author with her cousin Violet Martin of the *Irish R.M.* stories and of what some critics reckon to be the finest Irish novel, *The Real Charlotte*, studied art in Paris and was a painter and illustrator of real talent. "AE" also began as a painter and if he had treated

his painting as more than an avocation, he might have become Ireland's sole Symbolist artist of stature, apart from Harry Clarke.

In short, almost all the great figures of the Literary Revival were essentially *visuels*. With Joyce, a total change of orientation occurs, since Joyce seems to have possessed very little visual sense and in later life went almost blind, though in Paris he was contemporary with the greatest age of art since the Renaissance. (My late friend Arthur Power, who was both an accomplished writer and a gifted painter, often told me that in Paris he repeatedly tried to interest Joyce in the works of Picasso, Matisse, and their contemporaries but could never get any response apart from the lacklustre "how much are they worth?") Where his immediate predecessors had been *visuels*, Joyce lived primarily through his ear – he was of course highly musical, with a fine singing voice, and his Dublin dialogue is notated with the precision of a musical score, even down to the "rests". It goes without saying that the enormous international fame of Joyce, especially in America where his writings have found a second home, has done a great deal to shape the standard image of Irish culture abroad. The Irish are registered as the race with the gift of the gab, a blessing and a curse in one. This image, or shall we call it simply prejudice, has coloured apprehension of Irish literature and art all over the globe.

Going back a little in time, it is significant that Ireland produced important artists – Danby, Maclise, Foley, Mulready, and others – at a time when her literature was still relatively provincial and poor. In other words, the painters over the last two centuries have had the start on the writers and not vice versa. It is true that in the mid-nineteenth century we find Thomas Davis propagandising for a national school of painting (he mentions the fame of Maclise, Mulready and the sculptor Hogan, but regrets that they had virtually ignored Irish subjects), but Davis had little feeling for the visual arts and probably had in mind something parallel to the *Pilotyschule* in Germany. In fact, Maclise in certain of his pictures, such as *The Marriage of Strongbow and Aoife* in the National Gallery of Ireland, came close to meeting Davis's demands. Certainly in his great

frescoes in the House of Lords, he came nearer than any of his English contemporaries to producing the kind of major "history" painting which Delacroix, Géricault and Gros had given France. Maclise's emotional – though not political – patriotism is rarely recognised, yet it is constant throughout his career and in fact, like his friend Tom Moore, he was one of the creators of Irish cultural nationalism. Brooding elegiacally over Erin's past, he helped his country to discover itself and its national soul. In short, the rise of Irish painting, like the rise of Irish literature, is linked inseparably with Ireland's belated progress towards national independence.

In allying the vitality of Irish art with the rise of Irish nationalism, I am not trying to prove that all Irish art is or was overtly nationalistic. Certain Irish artists did identify themselves with Irish nationalism, notably Jack Yeats, but few of them were political activists and many of them spent much of their active lives in France, England or America. Orpen, for instance, turned his back altogether on the idea of Irish independence and the idea of "Irish art" *per se*, while Hone and Osborne concerned themselves with their craft and left politics alone. The kind of propaganda art which flourished briefly in the early years of the Irish Free State is little more than a period curiosity today, like Hitlerian art or the official Soviet art which flourished (if that is the word) under Stalin. Yet unmistakably, the same basic energy underlies both the art and the politics of the period – the urge towards self-discovery and self-expression, the laying claim to some place, however modest, in the sun, the sense of renewal and rebirth. This is not mere rhetoric or emotionalism, it can be parallelled in other European countries at the time, particularly those who had been subjugated by a more powerful neighbour whose social and political organisation was superior to their own. For instance, the similarities between nineteenth-century Ireland, Poland and Hungary during the same period have often been pointed out.

Nobody will seriously claim that Ireland's painters rival the art traditions of France and Germany, or even England; compared with them, she is obviously a nation on the European fringe. However,

the time is well past when European painting can be thought of as the prerogative of a few elite nations, or when a visit to Paris completed an artist just as his predecessors once completed their education by going to Rome. The decline of the School of Paris may have opened the way for the postwar American dominance, with all that implies both for good and bad, but it has also led to a major reconsideration of art history in general, particularly of the nineteenth and early twentieth centuries. One of the positive results of this has been the rediscovery of several virile, characterful "national" schools besides the dominant French School, each with their own validity and vitality, however local and limited much of it may seem to those narrowly obsessed with some axiomatic "European mainstream". We give due credit to national schools of literature outside Paris, London and Vienna; it is high time we did the same for national schools of art, using "national" in the best sense.

To cite an example, the recent, quite sudden popularity of the Scandinavian artists of the period (Hammershoi, Liljefors) not only shows how much life there still is in these Nordic painters with their half-forgotten names; it offers to countries like Ireland a very potent lesson. These were men and women who studied in Paris and other international centres of the day, where they absorbed all they could from the best teaching and the most advanced models of the time, and then, for the most part, went back home and painted their own country and native environment, its light and subject matter, without either lapsing into provincial cosiness and cliché, or becoming mere epigones of the French masters (Kirk Varnedoe, *Northern Light*, Yale 1988). It is partly in this kind of context that Irish art should be viewed and understood, not as some outlying province of London or Paris, though of course it had close links with both.

It is sometimes pointed out that Irish art was, until quite recently, virtually a monopoly of the Anglo-Irish – or more accurately, the Irish Protestant middle class, which is not quite the same thing. Perhaps this was inevitable, given the historic fact that for a long

time it exercised a corresponding monopoly of culture and education. These Irish Protestants, however, were inherently no less an Irish type or class than their Catholic compatriots, such as Moore and Daniel O'Connell. Ireland is a land of very mixed traditions, racially, linguistically, religiously and politically; and though Irish Protestants have often in their history tried to pass as English, the pretence has deceived no one – least of all the English themselves. Yeats, the literary Anglo-Irishman *par excellence*, always remained an Irishman to his London contemporaries. As for Maclise, his success with the drawing-room society of the Regency did not prevent him remaining as quintessentially Irish, both in looks and psychology, as Daniel O'Connell.

The so-called Anglo-Irish, in any case, were far from being culturally subject to the English, whatever their political allegiances may have been. Maclise absorbed a great deal from the German painting of his time, and after the mid-century it became almost *de rigueur* for Irish artists to study in France. This tradition remained strong until a generation ago, when French hegemony in painting collapsed. In fact, the entire slow, painful rebirth of Irish culture from the Romantic Age onwards could not have happened without the so-called Anglo-Irish, however they may have disliked the doctrinaire, neo-Gaelic Ireland of de Valera, to which it led.

All this took place against an intellectual background very different from the patrician culture of the eighteenth century. The nineteenth century saw the dawn of the "democratic" or mass society, when the legacy of the French Revolution took root even among countries and classes which had violently resisted it. It was the great age of the self-educated and the self-made, who could profit by access to public libraries, or at least to books produced in large printings at cheap prices; the age of public museums and galleries; of knowledge for the many rather than the few; of popular science and popular culture. It was, in effect, the birth of our modern mass culture, though shot through with a sense of intellectual aspiration which, for the moment, our Pop Age seems to have lost.

There was a hunger for self-betterment and for at least the outward trappings of culture, which previously had been the privilege of the titled and well-to-do. It was also, of course, the age of rediscovering the past, when scientific excavation brought buried cultures and civilisations again to light. And even if Ireland had nothing to excavate comparable to Ninevah or Troy, at least it could follow Tom Moore's exhortation and dream of the days "when Malachy wore the collar of gold which he won from the proud invader". Historicism and the creative imagination met and merged, to produce one of the most potent currents of the century and one of the chief strands in European Romanticism. If Irish literature did not produce a Scott or a Manzoni, at least it broke its colonial and parochial fetters, as had already happened in America, and pointed the way to the future. At least as much, if not a good deal more, could be said of Irish art.

Since a great deal of this book deals with Ireland's nineteenth century, it is opportune to look more closely at the birth of that century and some of the forces which shaped it. Though well-documented historically, it still lacks full cultural definition for us, or any clear-cut historical and aesthetic profile. The Victorian Revival, which in England is at least thirty years old and by now looks almost exhausted, has touched Ireland only tangentially and very late – for instance, the agitation of the past two decades against the depredations of Dublin "developers" has centred almost entirely on Georgian buildings, with very little said about the city's many fine Victorian and Edwardian buildings, some of them now gone forever. The eighteenth century is still the "snob" period, especially for a *petit-bourgeois* republic anxious to recruit a little historical glamour – a factor largely responsible for the burgeoning, and deplorable, school of neo-Georgian architecture.

Eighteenth-century Ireland produced some fine and relatively "native" architecture and crafts, particularly Irish silver with its elegant and very individual simplicity. In painting, however, it was

a relatively uncreative age and many or most of the artists who worked in Ireland were foreigners, "blow-ins" such as the portraitists Gilbert Stuart, an American, or Matthew Peters, born in Britain. There is scarcely a native-born sculptor of more than average talent, with the exception of Edward Smyth, though minor arts such as stucco flourished – much of it, admittedly, carried out by migratory Italians. Even Thomas Malton, famous for his *Views*, was an Englishman. In general, the arts and crafts were the privilege of the few – not solely the handmaidens of the landed aristocracy with their townhouses, but still very much a minority culture. Few people any longer take very seriously the simplistic image of a sparkling, cosmopolitan, patrician old Dublin killed off forever by the Act of Union and mouldering away ever more seedily, until it became the city of noisome Georgian tenements through which Joyce's Stephen Dedalus roams introspectively, a kind of Anglo-Irish Naples. Yet, by contrast, there is still a tendency to regard nineteenth-century Ireland as a culturally impoverished, and hope-lessly ingrown, provincialised country, until the Literary Revival began to take shape at the turn of the century.

Certainly, compared with London or Paris at the time, Dublin cuts a shabby enough figure. Ireland, with the exception of Belfast, missed out most of the Industrial Revolution, with its huge strides in science, technology and wealth and the new monied class of patronage which it threw up. It never produced a new mercantile and banking elite remotely comparable to Britain, nor were Dublin, Cork, Galway or Belfast ever great international ports on the scale of, say, Liverpool. (The prosperity of Cork was consider-able early in the nineteenth century, but its decline was rapid after that, both economically and in its population.) Yet the level of intellectual activity through the century is remarkable, in spite of socio-economic catastrophes such as the Great Famine and the running sore of the agrarian system. The truth is that Ireland was beginning to discover itself and to rediscover its past, to take stock of itself and to feel that it had a future and a place in the European complex that would make it something more

than a rather run-down province of the English-speaking
world.

Inevitably, much of this activity took on a deliberately nationalist
colouring, such as the Celtic Revival and the writings of the *Nation*
poets. Gaelic literature was rediscovered; archaeology and anti-
quarianism flourished; Thomas Davis agitated for a "national" school
of art; and a national Romantic literature finally began to take root
in Mangan and others. Yet much of the impetus came also from
people and even whole classes who were unionist and loyal to
Britain, though not necessarily hostile to Gaelic culture, for instance
the foundation of the Royal Hibernian Academy in 1823. Bodies
such as the Royal Dublin Society did sterling work in many fields,
museums were opened, exhibitions and musical events were
organised. Liszt, for example, visited Ireland and played in several
centres and how many people know that Géricault's *Raft of the
Medusa* was shown in Dublin at the Rotunda, in 1827?

Many of the ablest writers and painters moved to London, or
later in the century to Paris, but that is not surprising in itself. Under
the old Habsburg Empire, to quote an obvious parallel, artists and
intellectuals from its far-flung lands and regions similarly tended
to congregate in Vienna, in spite of the intellectual vitality of Prague
and Budapest. In a small island the urge to "go abroad" is always
strong – not only among artists, by any means – and the fame,
money and prestige that might be gained in the great cosmopolitan
centres was and is a continual spur to gifted, ambitious young
people everywhere. Yet these literary or artistic emigrés often main-
tained links with their homeland; Maclise, for instance, when he
was wealthy and famous in London, continued to send pictures
for inclusion in the annual RHA exhibitions. Much later, Orpen at
the apex of his fame and success came back to Dublin to help
reorganise the art-teaching system, and Hugh Lane gave unlimited
time and trouble, as well as many fine pictures, to set up a Dublin
gallery of modern art, at a time when he was one of the busiest
and most successful art dealers in the United Kingdom. It is true
that they sometimes met with the bleakest ingratitude and

misunderstanding, but the positive result of their legacy remains, while the backbiting and intrigues against them have receded into limbo.

Dublin, of course, is not and was not the whole of Ireland, and the nineteenth century was a period when the "provincial" centres in most countries supplied their own cultural needs, without benefit of television, or long-play records, or touring Arts Council exhibitions. Cork produced Maclise and the sculptor John Hogan, as well as other good artists who need not be mentioned here; Belfast had its own Northern talents such as Andrew Nicholl; Limerick turned out some artists of more than purely local interest; and Galway produced a portrait painter of ability in Joseph Haverty, who exhibited at the Royal Academy in London and has left a good portrait of Cardinal Wiseman. Catholic Emancipation had gradually opened up the "fine arts" to more than Protestants, and the previously despised Catholics were increasingly infiltrating art and architecture as well as literature. In architecture, the English Catholic Pugin cleared the way for his gifted Irish pupil McCarthy, who actually designed the church for Pugin's college complex in Maynooth, Co. Kildare – the seat of the Catholic hierarchy in Ireland, and so one of Ireland's power bases for a century.

1

The Irish Romantics

IRISH ART in the eighteenth century is not greatly interesting, as has already been said, in spite of a recent tendency to discover an "Irish school" of landscape painters. Artists such as William Ashford, Thomas Roberts, and a handful of others are now eagerly sought after in the salesrooms, and at their best they are spacious, dignified and with a fine sense of style. What is lacking in their work as a whole is any really strong character or personality; they are barely distinguishable from at least two dozen English painters of the period and are, in effect, a provincial English school, though a talented and interesting one. George Barrett (*c.*1730-84) is more individual and less stereotyped, with a certain wildness and ruggedness at times which mark him as a kind of proto-Romantic, though just how "Irish" his style and mentality are remains problematical.

Almost the only Irish painter of the period who has more than a local reputation is James Barry (1741-1806), whose achievement was recently celebrated with an exhibition at Burlington House, in London. This is not the place to discuss Barry at length – those who want such a discussion in depth are referred to the excellent chapter on him in *The Painters of Ireland* by the Knight of Glin and Anne Crookshank. Yet in many ways he is a microcosm of the Ireland of his time – uneasy, autodidactic, straining for a place in the sun but burdened with all the outsider's chips and edges; more intelligent in many ways than those around him, but laden with ambitions largely beyond his scope or technique. Barry is

ultimately a tragic figure, since the "history" painting he believed in so ardently – like Benjamin Robert Haydon a generation later – was not essentially what suited his talents best. His frescoes in the Royal Society of Arts, London remain works which are lofty, ambitious, even grandiose in their conception and aspirations but mechanical and lifeless in terms of sheer execution. Barry's passionate belief in himself and in the future of this kind of art convinced many besides himself, including the great Irish orator and political thinker Edmund Burke. Like Haydon again, he was, in many ways, a sacrifice to the times; others built on his legacy. He is also, in several respects, the prototype of the Irish interloper in London, who either takes refuge in embittered isolation, or plays the court jester. Barry did the former.

By contrast, the far more modest personality and limited range of the landscapist James Arthur O'Connor (*c.* 1792-1841) produced sensitive, sincere pictures which have lasted better than the bulk of Barry's grandiose efforts. O'Connor was shy and unbusiness-like, apparently rather gauche socially, and like so many artists who lack inner self-confidence, he was unsure of exactly where his main strength lay. A great deal of his output (though since there are many forgeries, it is hard to be sure exactly just how many surviving works are genuinely his) is frankly commonplace; chronically short of money, he turned out many potboilers, painted quickly and to a formula. The usual O'Connor picture of this type features small figures with red cloaks against a conventionally pastoral background, and the scale is rather small, like that of Sadler and certain other busy, competent minor artists of the time. O'Connor is more impressive, but hardly more individual, when he becomes Italianate and cosmopolitan, and paints the wild, wooded, inspiring region of the Mayo seaboard to make it look rather like the Bay of Naples.

This is the typical, all-too-familiar case of a provincial artist trying to ape the international fashions at second hand. But there is another side to O'Connor, which makes him stand out from his narrow, frustrating milieu – a daring, dramatic, almost visionary streak which goes far beyond the conventional picturesque and

puts him squarely in the Romantic Movement. *The Poachers*, in the National Gallery of Ireland, is an extraordinary nightpiece, tense and almost sinister, and I feel that "international" Romantics such as Washington Allston would have appreciated its poetic mood and originality. The poachers – diminutive figures – stand caught and transfixed in a sudden flood of moonlight, as they might in some melodramatic scene from a Carleton novel. O'Connor also shows visionary flashes of an elemental feeling for nature which has less in common with English Romanticism (though he seems to have admired and even imitated Constable) than it has with the nature element of Gaelic poetry, which O'Connor almost certainly had never read. Again, O'Connor had relatively little success in England and a good deal of his short, rather thwarted life was spent on the Continent. Since he painted a good deal in Germany, it is tempting to speculate on whether he saw any paintings of Friedrich, Carus, Blechen or the other German Romantic landscapists.

When O'Connor made his first, disastrous, trip to England in 1813 he was accompanied by two young and ambitious artist friends, George Petrie and Francis Danby. Danby (1793-1861) belonged to a yeoman-farmer family in Wexford which had moved to Dublin in the wake of the 1798 Rebellion and was probably of Cromwellian settler stock – a more rugged and self-sufficient character than O'Connor, who had probably given him lessons in painting. In London almost nothing went right for them, so Petrie returned home to make a reputation as a painter of antiquarian subjects and eventually rise to be president of the Royal Hibernian Academy; Danby and O'Connor trekked by foot to Bristol and arrived there penniless. Typically, O'Connor failed to find local buyers for his work, so he too returned home, while Danby did so well that he decided to settle there (according to tradition, O'Connor had to borrow the fare home to Ireland from his friend). Bristol at this time was a city with not only a thriving commercial life but with an intellectual and artistic vitality which made Coleridge, for instance, feel so much at home there. Today, when British culture is centred almost claustrophobically in London, it is often hard to

realise how much of the greatness of nineteenth-century England came out of its provincial capitals, and the level of scientific, literary and artistic activity which existed in these without the state subsidies which we consider so essential today. Danby was a man of some culture, literate and reasonably well read, who mixed with writers as well as fellow-artists and built up a solid local reputation as a landscape artist until he was sucked – very willingly, it seems – into the art world and politics of regency London.

His work of the "Bristol period" is predominantly pastoral, rather small in scale, and with more charm than power. In retrospect, it is hard to link these mild, rather unoriginal small paintings with the kind of *grand sujet* which brought him European fame and which had endless imitators – apocalyptic or biblical scenes such as the Flood, shipwrecks, storms at sea, angry or ruddy sunsets. He is one of the few figures in the whole of painting who has disproved the axiom that a sunset cannot be painted without lapsing into tonal *blancmange*. Danby's rather sudden conversion to this grandiose ultra-Romantic style has generally been put down to Royal Academy politics, to the influence of Turner, and to his own ambition to rival and surpass John Martin, the English painter of Apocalypse *par excellence*. This, however, is a simplification which reduces him to the level of an imitator and artistic opportunist – a palpable misreading of his character as well as of his work. Danby was certainly a man of his time, and while the Turner influence is unmistakable, the lurid, Inferno-colour which is the hallmark of much of his work was not only the legacy of painters such as Loutherbourg, but was the product of the early stage of the Industrial Revolution and its dark satanic mills. Like Blake, Danby was also reacting to the long, fearful period of social and political convulsion inaugurated by the French Revolution, which made many thinking people believe that they were indeed living through a real-life Apocalypse.

Danby was also influenced by such devices as the diorama, which showed to crowds of viewers the Battle of Waterloo and other "panoramic" events and was, in effect, a remote ancestor of the

CinemaScope screen. Some of this has a strangely modern sound, in view of the current interest in "environmental art" and the tendency of certain recent American painters to create large abstract pictures which envelop and draw the viewer into their ambience and glow. Danby, in fact, is a pioneer of the "Abstract Sublime" so much talked about a few years back, and both tonally and imaginatively he has something in common with American artists such as Rothko and Clyfford Still. Some of his best-known paintings hang in the Tate in London, including the poetic *The Wood Nymph's Hymn to the Setting Sun* (now apparently credited to another artist) and the huge, livid *Deluge* which is in rather poor condition and shows his gifts already past their apogee. The National Gallery in Dublin hangs another of his familiar apocalyptic pieces, *The Opening of the Sixth Seal*: brazenly rhetorical, tonally claustrophobic, but undeniably grandiose and powerful, the product of an imagination with a genuinely molten, incandescent core. The Victoria and Albert Museum hangs one of his masterpieces, *Liensfiord Lake, Norway*, which shows how deeply Danby understood the mood and reacted to the emotional world of Nordic romanticism with its livid light, lashing waves, lowering cliffs, and overpowering sense of nature indifferent or hostile to man. Against these massive stormpieces should be set the tranquil, contemplative side of Danby's output, epitomised in the ethereally beautiful *Dead Calm – Sunset at the Bight of Exmouth* which belonged to one of Danby's most eloquent modern defenders, the poet Geoffrey Grigson. Here the mood is close to Turner's *Evening Star*, and also close to Caspar David Friedrich and even to certain American Romantics. Against the evening sky, two ships swing at anchor, their bare masts and spars mirrored in the glassy sea, while to the left the smoke from a passing train moves away along the shore and on the right, some barely seen fishermen light a fire beside a beached fishing smack. It is a painting with a poetic mood so rapt, you feel that at a touch it could shatter like a glass mirror. Like a true son of Wexford and citizen of Bristol, Danby was a keen sailor who not only sailed his own yachts, but even built them. It is a curious parallel that

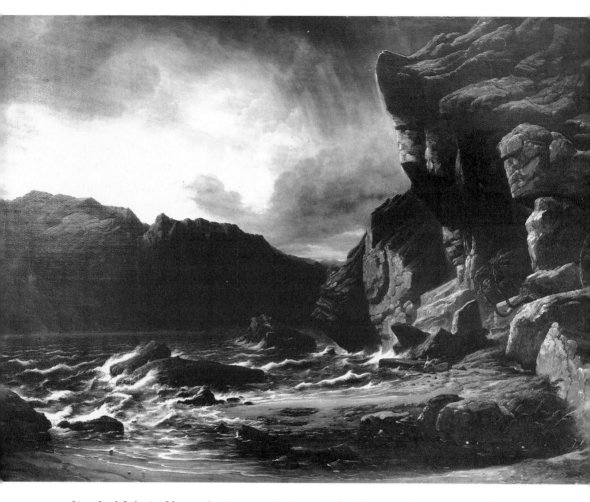

Liensfiord Lake in Norway by Francis Danby (*c.* 1841). The emotional world of northern European romanticism had a special appeal for Danby, who travelled widely on the Continent.

Martin, his rival, invented a patent sea anchor; Victorian artists were prodigal inventors and all-rounders.

Just how much he did owe to Martin is problematic, and it is likely that Martin owed him something in return. Possibly each found the other "damned good to steal from", as Fuseli said of Blake, though Danby was recognised as the better draughtsman and finer technician. A matrimonial scandal wrecked Danby's burgeoning career in the Royal Academy (unlike Turner and his fellow-Irishman William Mulready, he was not discreet enough to keep his private life private) and like Byron before him, he left England in disgrace for the Continent, an exile or *Wanderjahre* which lasted over a decade. Bringing in the name of Byron seems almost unavoidable, in view of how close Danby is to the English Romantic poets – he even painted an *Alastor*, and certain of his works can be seen as visual parallels to passages in Coleridge, Byron and his own friend Beddoes. *Disappointed Love* (Victoria and Albert Museum) shows an unexpected side of him which is close to the Pre-Raphaelites – intimate, lovingly detailed, almost Tennysonian. Is the girl – plainly crushed by the letter she has just read – about to drown herself in the alluringly beautiful pond beside her?

The greatest weakness of Danby's work, apart from the repetition and the bombast, is that much of it is technically unsound, the product largely of bituminous pigments and certain unstable colours manufactured at the time. (The same is true of Turner, many of whose pictures are now in decay, with their tonal balance destroyed forever and submerged in hot coppery tones.) Yet in spite of his tonal monotony, his rhetoric and his vein of cavernous gloom, he is a Romantic of European size; and through him and O'Conor, Ireland made a contribution to international Romanticism which rises far above the provincial Irish art milieu of their time. He remains an original and a genuine visionary, who has too often been denigrated as John Martin's alter ego, or else as an inflated second-rater subsumed by the solar glow of Turner's genius.

2

Maclise: The Irish Victorian

IN 1838 the novelist Thackeray, who was also a practising art critic, set out humorously his order of merit for the leading artist of his day – English of course, or as he calls it, "the greatest school of painting of the greatest country in the modern world". His list is as follows:

1. Baron Briggs (At the very least, he is out and out the very best portrait painter of the set.)
2. Daniel, Prince Maclise (his royal highness's pictures place him very near the throne indeed.)
3. Edwin Earl of Landseer
4. The Lord Charles of Landseer
5. The Duke of Etty
6. Archbishop Eastlake
7. His Majesty King Mulready

It is worth noting that the two men elevated to royal and princely rank are Irish: namely Mulready and Maclise. Mulready (who recently has been honoured with a bicentenary exhibition at the Victoria and Albert and the National Gallery of Ireland) was obviously closer to Thackeray's tastes through his refined, rather small-scale art, which reconciles the mystical and pastoral intensity of Blake and Palmer with the mid-Victorian world of domestic genre.

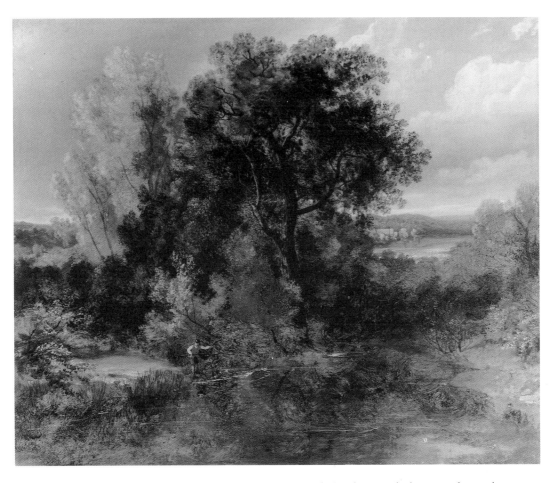

The Pool by William Mulready (*c.* 1810). Mulready's landscapes belong to the early stage of his career, before he turned to genre painting.

Mulready is undoubtedly one of the genuine Little Masters of early Victorian art, but though he was born in Ennis, County Clare, there is very little in his paintings which lifts him out of his English context. His delicate, luminous colour and his technique of working on a white ground definitely influenced the Pre-Raphaelites, but he was a slow producer with a limited range. His very virginal nudes somehow drew the wrath of Ruskin, who wrote some particularly silly things about them (he called them "most abominable"). Maclise, on the other hand, the son of a Scottish soldier who had settled in Cork and whose real name was probably MacLish or MacLeish, played a role in the developing national consciousness of his country – or rather of both his countries – which Mulready, the "native" Catholic, never dreamed of. Most English art historians and critics have tended to ignore this and continue to regard Maclise as one of the most archetypically English of the early Victorians, but he cannot be understood if the Irish dimension in his art and mentality is ignored.

At the time Thackeray conferred his honorary princedom on him, Maclise was in his early thirties (he was born in 1806) and was already an artistic and social lion in fashionable London circles. He had moved from Cork to England as a youth and studied in London, where he showed a social ease and charm to back up his Byronic good looks and obvious talent. His success was rapid and it was helped by his friendships with leading literary men – Dickens, Thackeray, Bulwer Lytton, all of whom he painted. Influential Regency and early Victorian hostesses took him up, which in one case led to a scandal when he almost eloped with Lady Sykes, the wife of his patron Sir Francis Sykes, who was much older than he was and who was what used to be called a "woman with a history". In short, he enjoyed the easy, polished, permissiveness of the age and was fully in tune with it, painting mainly in a genre style close to Wilkie's and also in the rather gaudy, theatrical, over-costumed style of historical subject popularised by such people as E.M. Ward and C.R. Leslie.

It is easy to label the young Maclise as an opportunist, yet he

seems to have been good-natured and adaptable rather than calculatingly ambitious. The Irish were beginning to make their mark in English art, literature and society, and Maclise came close in time after Tom Moore and the novelist Lady Morgan, both of whom had been lionised in London – the first for his talent and drawing-room charm, the second for her talent and drawing-room eccentricity. This generation, rather than that of Sheridan a generation earlier, was the real forerunner of the type of absentee Irish writer in London who combined the roles of court jester and social critic: Shaw, Wilde, Brendan Behan *et al.* Maclise, who charmed everybody and had no enemies, became the favoured guest of the best houses and the boon companion of Dickens and Thackeray and their respective sets. Through his connection with the renegade Irish journalist William Maginn and other literary emigrés, such as Crofton Croker and "Father Prout", he also got to know the whole *Frazer's Magazine* set, including Coleridge and Carlyle, whom he drew.

Inflamed by Scott and the German Romantics, Romantic medievalism was then at its height, whether it took the more serious and substantial form of the Gothic Revival or the contemporary aristocratic fad for jousting. Maclise even painted Sir Francis Sykes and his Lady in medieval dress, the husband in armour and carrying a lance. (For a parody of the neo-medieval craze, taken to absurdity, *vide* that delectable character Mr Chainmail in Peacock's novel *Crochet Castle*.) Most of this neo-medievalism was as shallow and ephemeral as the chinoiserie of the eighteenth century, but it represented the frothy surface of a powerful underlying current which virtually transformed Maclise's art. Already nationalism in Europe was becoming a flood tide, stimulated both positively and negatively by the Napoleonic age, which had undermined or shaken the old dynastic system and the old empires while, by its own imperial thrust, it aroused strong national counter-currents in Germany and elsewhere. In particular, the smaller and more oppressed nations of Europe – Hungary, Poland, Finland and of course Ireland – began to refurbish their

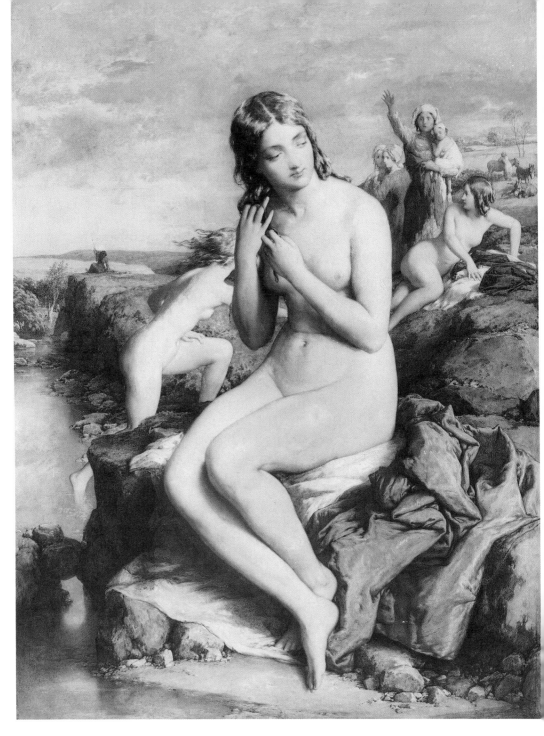

Bathers Suprised by William Mulready (1849). Today Mulready's nudes seem virginal, even coy, yet they incurred the moralistic wrath of John Ruskin when first painted.

histories, folklore and legends, and to re-live their past.

In this context, the two major figures closest to Maclise in mentality were Moore and Scott, both spokesmen for small Celtic nations sucked into the imperial English orbit. Scott, of course, was not himself a nationalist, or at least not a separatist, but he virtually created "local colour" – what the Spanish call *costumbrismo romantico* – as well as recreating the whole historical pageant of the Age of Chivalry in a sanitised, picturesque mode which his age could accept or even emulate. Moore certainly was a conscious nationalist, though not a revolutionary, and those later Irish revolutionaries who regarded him as something of a court lackey and *jongleur* to London society were doing him a real injustice. Moore was usually glad to accept official patronage. He was naively and openly vain about his literary and social success; but he was also a genuine patriot, and songs such as "The Minstrel Boy" came straight from the heart and went straight to it in turn. He really did love his poor, confused, misgoverned and often despised country, felt deeply about her wrongs and her maligned name and was proud of her ancientness and her half-buried culture. His patriotism, of course, tended to brood elegiacally on the past rather than to sound a nation to arms, as most of his embattled Hungarian and Polish contemporaries did. This quality gave him extra appeal for Maclise, whose character under its apparent bonhomie and alertness had a core of fatalism and even pessimism which has often been remarked on. His battle scenes, for instance, show more of the horrors of war than its glories.

His illustrations to Moore's *Melodies* prove how close they were to each other mentally, even to the broad streak of conventional suavity which exists in both men. Yet while these literary influences were strong on Maclise, a well-read man in his own right, there were other, equally powerful currents reaching him from continental painting. The entire Napoleonic period, with its heroic and martial trappings and its campaigns which spanned whole continents, had of course given enormous impetus to a revival of "history" painting, initiated by David and Baron Gros and continued by

Delacroix, Delaroche, Achille Deveria and others. But a new chapter
in this was opened with the spectacular success of the so called
Antwerp Colourists, headed by Baron Wappers, which routed the
Neoclassic school and for at least a decade was imitated all over
Europe. In Germany, their disciple Piloty similarly routed Kaulbach
and Von Cornelius and the last of the so-called Nazarenes and, ruling
from Munich, he became a virtual dictator of his countrymen's taste
(rather like Joseph Beuys in the 1970s, or more recently, Anselm
Kiefer). This new movement was in many respects a visual equiva-
lent to the historical romances and plays of Dumas and Hugo, but
it had an extra, nationalistic relevance because its emergence coin-
cided with the 1830 revolution in Brussels, which threw out Dutch
rule and established modern Belgium as an independent state. The
obvious parallel with Ireland cannot have been lost on Maclise, even
though he was no revolutionary himself, or even a political radical.

Maclise's transformation from a Regency dandy and genre artist
into a history painter on a heroic scale can only be understood
in this wider European context. The large canvas (122 x 199in.)
in the National Gallery of Ireland, *The Marriage of Strongbow and Aoife*
(first shown at the Royal Academy in 1854), is clearly indebted to
continental Romanticism, and the figure of a woman with uplifted
arms just right of centre, wailing over her dead, proves that he
knew Delacroix's *Massacre at Chios*. The pointed – almost too
pointed – contrast between the mailed, victorious, proud Normans
and the scenes of slaughter and desolation around them shows
plainly where Maclise's historical sympathies lay. And the theatrical,
"tiered" composition shows an awareness of stage and operatic
settings of the time – it could almost illustrate some Meyerbeer
grand opera, such as *Robert le Diable*.

Maclise was among the artists chosen officially to decorate the
new Houses of Parliament after the old one had burned down in
1834 – an event recorded in Turner's well-known painting. He
began with two rather conventional works, *The Spirit of Chivalry*
and *The Spirit of Justice*. These relatively minor works were a kind
of trial run for the two huge frescoes in the Throne Room of the

House of Lords: *The Meeting of Wellington and Blucher* (after Waterloo) and *The Death of Nelson*. The summation of his career, they cost him years of work (1858-64) and preliminary study and in fact virtually finished him, physically and emotionally, since the enormous sustained effort (he worked virtually without assistants) left him in a state of nervous depression and exhaustion from which he never really recovered. (Mural painting was terribly exhausting and unhealthy, and broke the health of several artists – Delacroix's murals in the church of Saint-Sulpice virtually killed him. These vast, unheated spaces were particularly unhealthy in winter.) By the time of his death, he had become a virtual recluse – so much for the Regency buck of forty years earlier! His withdrawal from public life even led him to reject the presidency of the Royal Academy, which in his prime would have crowned his career. His friend Dickens delivered his funeral elegy.

Tragically, these works are in a poor and decayed state physically, since Maclise was induced by all sorts of pressures – including a personal appeal by Prince Albert – to use the German technique of "water-glass" painting. This apparently involved spraying the surface of a picture with liquid silica, but it was a technique still in its early stages and it did not save Maclise's masterworks from decay. The black-and-white chalk cartoon for *Blucher and Wellington* still survives, an impressive feat of neoclassic draughtsmanship, and in the Walker Gallery in Liverpool you can study the large oil sketch for *Nelson* for an adequate image of what the colours of the final version must have looked like when new. This was exhibited at the Royal Academy in 1866 under the title *Here Nelson Fell*. Typically, these works intended to glorify two climactic English victories end up by being virtual indictments of war; in *Wellington* the dead and dying are more prominent than the two Allied commanders and their aides, while in *Nelson* there is more stress on dumb, unthinking, almost animal endurance and suffering, than on stereotyped Victorian heroism. Maclise's attitude to war ended up being sombre and even Tolstoyan. Once again he had moved with the times, from Romanticism into mid-century Realism. *Wellington*,

in particular, might almost illustrate *War and Peace*, and the weary handshake of the British and Prussian generals-in-chief on the terrible field of battle rises above mere rhetoric.

Today, of course, it is only too easy to see Maclise's eclecticism and theatricality, his borrowings from his French, Belgian and German contemporaries both as a painter and illustrator. (He travelled in Germany and met many of the leading German artists there, inspecting as well many of their works. German art, from the Nazarenes to Menzel, was very influential in England.) Yet he was also a considerable innovator and original in his own right, and even the Pre-Raphaelites, who detested most of his RA contemporaries including Frith and Landseer, came to regard him as one of their precursors. Ford Madox Brown and Holman Hunt show his influence very strongly, and his own version of Keats's "The Eve of St Agnes" in the Walker Gallery in Liverpool, *Fair Madeleine*, shows that he could rival them on their own ground. As a populariser of history whose works were very widely reproduced, he is second to none; he was, in fact, a kind of Walter Scott in paint, and at least two generations of English and Irish schoolboys grew up seeing episodes of their history literally through his eyes. Maclise was, in short, one of the key cultural personalities of his milieu, and a moulder of its entire outlook. As a "history" painter, he succeeded where Barry and Haydon both had failed – in creating a great "public" art.

Pre-Raphaelitism, incidentally, is not a movement which made much impact on Irish art, though in literature its later stages strongly influenced the young W.B. Yeats, among others. An artist on the fringe of the movement was William Davis (1813-73), who emigrated from Dublin to Liverpool and was so thoroughly absorbed into the very vigorous North of England art world of the time, that English critics and historians are sometimes surprised to hear him spoken of as Irish. Davis was essentially a landscape painter, and if one calls him Pre-Raphaelite it is largely because of his combination of sharply rendered detail and Romanticism of mood, rather than because of the fact that Rossetti and Ford Madox

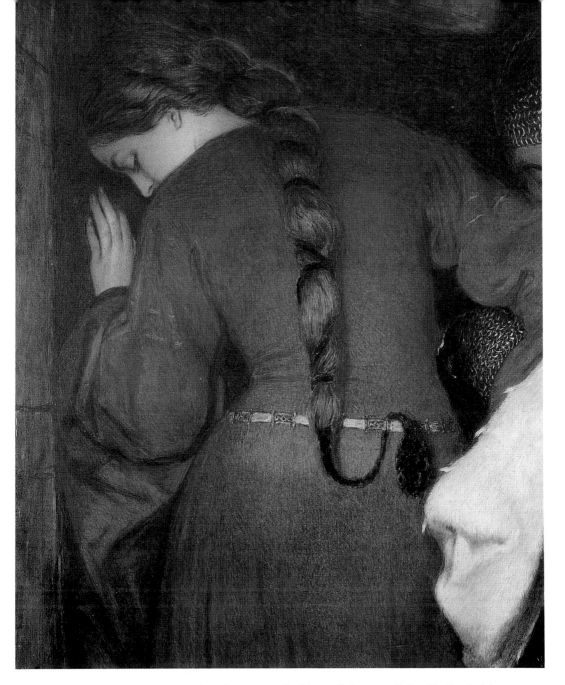

Hellelil and Hildebrand, or *The Meeting on the Turret Stairs* (detail) by Sir Frederick Burton (1864). This large watercolour illustrates a romantic ballad and shows Burton as a kind of Irish Pre-Raphaelite.

Brown admired him. (Ruskin, by contrast, did not.) His landscapes are often unpeopled, which enhances their contemplative, poetic stillness and Keatsian magic, yet they are closely and lovingly observed. Works by him hang in the National Gallery in Dublin and in the Walker Gallery in Liverpool.

There is Pre-Raphaelitism of a more obvious kind in certain works of Sir Frederick William Burton (1816-1900), whose creative ability was largely swallowed up later in life by his duties as the director of the National Gallery in London. His large watercolour *Hellelil and Hildebrand: the Meeting on the Turret Stair* (National Gallery of Ireland) belongs to the same world of Nordic Romanticism which influenced Maclise, but the colour is richer, subtler and more sensitive than anything Maclise ever achieved; it could almost be by Millais or Arthur Hughes at their very best. Only a handful of Burton's other works have anything like the same magic and his once-famous and much-reproduced *The Fisherman of Aran's Drowned Child*, with its depiction of manly grief and keening women, is Victorian sentimentality of the most wince-making kind.

There is no really outstanding Irish portraitist of the nineteenth century, nor had there been in the eighteenth. Sir Martin Archer Shee (1769-1850) was a powerful and supple personality who worked mostly in England and became president of the Royal Academy. His work follows very closely in the tradition of Lawrence, Reynolds and other eminent Englishmen: mainly society portraiture of the most polished kind, but without any strongly personal flavour. His portrait of Thomas Moore, the national bard, in the National Gallery of Ireland is as good as anything he ever did and has never gone out of fashion. Alas, Ireland never in this period produced a portraitist even remotely equal to the Scots Raeburn and Allan Ramsay a generation before.

3

The French Connection

DANBY AND Maclise died within a decade of each other, and in their lifetimes the art world changed probably more radically than it had done in centuries. The new Realism was now triumphing everywhere, even though the third quarter of the century saw a strange revival of Neoclassicism in a new aesthetic guise, and Impressionism was just around the corner. Above all, the revolution had happened by which painters could work out of doors for long periods (and on full-sized canvases, too) thanks to a technical innovation, the tube of paint. Previously, out of doors painting had mainly been done in watercolour, though sometimes oil sketches were made which later were enlarged and "worked up" in the studio. From the mid-century onwards, the *Zeitgeist* drove the artists more and more out into the open, just as half a century later another *Zeitgeist* drove the people of Northern Europe down south to soak up the Mediterranean sun and air, and to bare their bodies in reaction against the overfed, overdressed, over-sedentary life-style of the late nineteenth-century middle classes.

While Maclise was labouring daily in the House of Lords, to the ruin of his health and nerves, a young Irishman was already absorbing the lessons of the new styles in France, which became a second home for him. He had the same name as his eminent eighteenth-century painter-ancestor Nathaniel Hone, but oddly enough he began as an engineer trained at Trinity College, Dublin, that traditional bulwark of the Irish Protestant upper-middle class. Hone

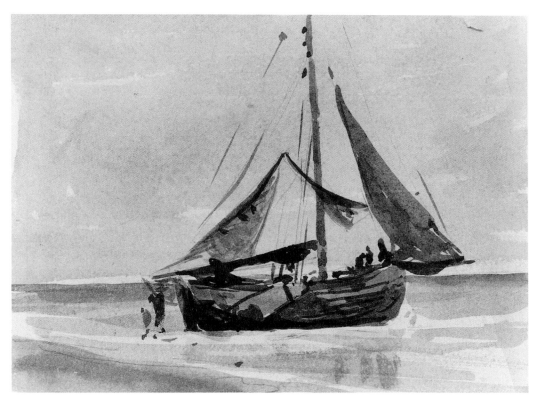

Fishing Boat on Beach at Scheveningen by Nathaniel Hone the Younger. Hone's remote ancestry was Dutch and he seems to have been drawn to the land of his forefathers.

worked for a time on Ireland's developing railway system, then considered emigration to South America, but instead opted for studying art in Paris. His chief teacher there was Thomas Couture, then doubly famous for his enormous picture *The Romans of the Decadence* (now on show in the Musée d'Orsay, after long years of obscurity) and for his advanced teaching methods. (Manet was one of his pupils.) Couture's method stressed free, painterly handling, and he also encouraged young painters to work out of doors.

Hone settled in Barbizon, the nerve-centre of landscape painting, where he became a friend of Corot's and met all the other great figures there, including Millet, who as he later recalled was glad to sell a picture for forty francs at this time. He also met Manet – "a regular dandy" – and other leading Impressionists, but Hone was never really interested in Impressionism *per se*. Like the Barbizon artists, it was the permanent elements in nature which absorbed him, not fugitive effects of light or atmosphere. Like Theodore Rousseau's, his pictures brood nobly or intimately, inside a rather low tonal range; they do not have the iridescence and broken colour of Monet or Renoir, and they make few concessions to charm or Parisian *joie de vivre*.

By the time Hone returned to Ireland to live the life of an Irish gentleman farmer at Malahide on the coast north of Dublin, he was middle-aged and a complete cosmopolitan. He was a man of independent means, in the old phrase, and though he exibited regularly in Ireland, painting for him was an avocation and not a profession – he does not, for instance, seem to have worried much about sales, and in fact sold relatively little. In Dublin this gave rise to the myth, possibly fuelled by professional and class jealousy, that he was essentially a gentleman amateur who painted as a hobby, while living off the land. As late as twenty years ago, I heard the Dublin painter Harry Kernoff (whose professed communism may have influenced him) expostulate to a visiting American artist who had been impressed by Hone's paintings: "Nat Hone? But he wasn't a painter, he was a gentleman farmer!" Old myths die hard and

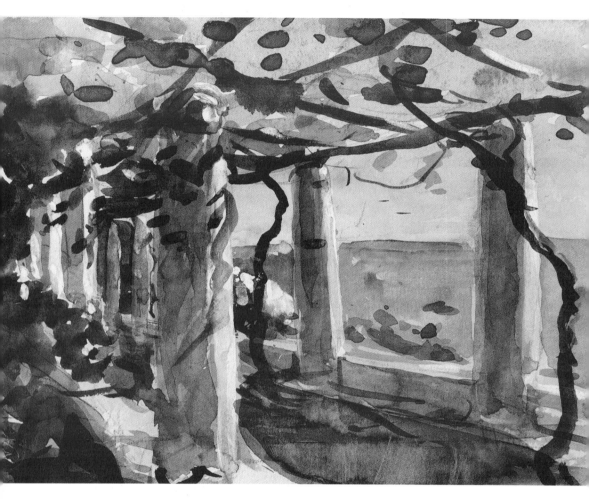

A Vine Pergola by Nathaniel Hone the Younger. One of the many records of Hone's frequent travels abroad.

though Hone always had admirers, including George Moore, "AE", J.B. Yeats, and Thomas Bodkin, his disclination to push his reputation during his lifetime continued to harm his reputation post-humously. Even in Ireland, his real stature is only being slowly and reluctantly recognised, and in England even the connoisseurs have scarcely heard of him.

Another obstacle in the way of recognition was that he lived through the Impressionist revolution and on into the start of the Modern movement, by which time he looked hopelessly out of date, a nineteenth-century dinosaur. Impressionism changed the whole tonality and colour key of painting, making Hone's palette look murky and dull, even monochrome. He was actually a master of painting in low tones, making rich and subtle use of the earth colours, grays and drab greens – tonal areas we are only now beginning to rediscover, after the light-flecked tones of Impressionism and the post-Matisse emphasis on flat areas of primary colour. In his early French period his palette was generally lighter and airier, but when he settled on the coastal area of Malahide, great brooding skies and low-lying expanses of sea and sand dominate his pictures more and more, so that the horizon line is often narrowed to a mere ribbon, weighed down and almost crushed by massive skies. *Evening, Malahide Sands* (Hugh Lane Gallery, Dublin) is an almost monochrome tonal symphony in which landscape details are blotted out and everything is merged into one dominant mood or emotional key, at once intimate and majestic. In works such as this, Hone appears as almost a precursor of abstraction, though it is most unlikely that he would have liked the term even if he had understood it.

Lonely, brooding and elemental in his art, Hone in private life seems to have been bluff, moderately sociable, well liked by fellow-artists, and happily married. Yet figure paintings by him are relatively rare, though his watercolours and drawings prove him well capable of drawing the figure when he cared to do so. He travelled a great deal, painting as far off as Egypt, but it is not for his pictures of exotic places (for instance, the Pyramids) that one remembers him.

He has been linked with Constable, and there are some parallels with early Steer, but he is no more an English painter than he is a specifically Irish one. The formative Barbizon influence is plain, and so is the debt to Courbet – Hone's magnificent stormy seascape *Rocks at Kilkee*, painted on the coast of County Clare, is clearly descended from Courbet's *La Vague*. Yet there is also the legacy of an older, more Northern European tradition, going back to Wouwermans and van der Velde, painters of the sea and wet, low-lying coastal lands, wide estuaries and lowering skies. Even when living in France, Hone was temperamentally drawn to the work of such Lowlanders as Mesdag, Maris and Jongkind (he is known to have copied some of them) who excelled in painting spacious, almost empty vistas of sea and sky. Hone's family was Dutch some centuries back, so it may have been a submerged racial pull which drew him to the painters of his ancestral regions.

Certainly he is a painter who can be hung in the very best company and still demand to be noticed in his own right. I cannot think of any English contemporary who can compare with him on his own ground – Sickert, for instance, would look coarse and journalistic beside the best Hones, with their breadth and tonal subtlety and sheer power. Yet the average British or French historian has hardly heard his name, in spite of Hone's years in France, or the fact that he was bought by the Luxembourg Museum during his lifetime and was heavily represented in the Franco-British Exhibition of 1908. For many years there was no large-scale exhibition of his work, until the Dublin National Gallery (which owns an incomparable collection of his pictures bequeathed to it), mounted one in 1990, with an excellent catalogue-cum-study by Julian Campbell. Meanwhile private collectors, who are usually more enterprising and knowledgeable than public ones, have been discovering Hone for themselves and his salesroom prices have risen steadily, particularly in London. And though he has been a solitary figure in Irish art, he was much admired by certain leading Irish painters, including Patrick Collins.

Walter Osborne (1859-1903) for some reason is often bracketed

with Hone – Irish people habitually say "Hone and Osborne" – though the two men were of different generations and different styles. Hone is a painter of great vistas of sea and sky, while Osborne's landscapes are more intimate and genial, as though inviting the viewer to walk into them. In fact, though Osborne seems personally to have preferred painting landscapes before anything else, probably his finest pictures are interiors, or else genre pieces with an outdoor, light-filled background such as a garden. Like Hone, he was eclectic and fully aware of continental art – he studied in Antwerp – and he belongs in essence to the late stages of *pleinairisme*, softened a little by the Impressionist influences which by then were filtering in everywhere. Osborne's mentality was predominantly *intimiste*, lyrical and even feminine, though personally he was very much a man's man, fond of cricket and male company.

Osborne admittedly lacks Hone's scale and breadth, but he is a good deal more versatile and varied, and the general public continues to find him more human and approachable. Luminous interiors such as *The Lustre Jug* show him as a more conservative but equally sensitive Vuillard, and in *St Patrick's Street* the face of the fishwife and passers-by reflect the often unconscious pathos of the poor – a motif echoed in many other Osborne paintings, including one of his masterpieces, *In the Phoenix Park, Dublin – Light and Shade* (National Gallery of Ireland). This quality is not the mystical or biblical identification with the poor of this earth found in Van Gogh and other continental artists of the time, and which often has socialist undertones. It is closer to the quiet, humane, very middle-class sympathy and insight found in a whole sector of late Victorian and Edwardian art and literature, such as Gissing's novels, or George Moore's *Esther Waters*. Without it, Osborne would be little more than the stylish *intimiste* of upper-middle-class Irish Protestant life, the quintessential painter of tea on the lawn, flowers on the table, and notably well-behaved children.

Like Hone, Osborne often found it hard to sell his landscapes and since, unlike Hone, he had no private means or income, he

was driven to painting portraits for a living. It was not a field he much cared for, and this as much as anything else gave rise to the distorting legend that he was not very good at it. Certainly his portraits are uneven overall, but this variation in quality seems to have been conditioned a good deal by his personal response to the sitters and by whether or not he found them sympathetic. A large percentage are, quite simply, bread-and-butter jobs done for rather boring people, whom no amount of talent could have made interesting or paintable. At his best, however, Osborne is a portrait-ist of rare sensitivity, particularly of women whom he painted always with insight and understanding. Some of these portraits are in the grand style, showing not only Osborne's typical delicacy of touch but an unexpected bravura. The decorous, genial late Victorian was feeling the pulse of the *Belle Epoque*, and his final, light-flecked works suggest that he was reacting to the posthumous influence of Manet.

Thomas Bodkin in *Four Irish Landscape Painters* complains that there is "nothing distinctively Irish" in Osborne's work and that "he does not seem to have any special sympathy or understanding for Irish character, or even for Irish landscape. I think his ancestry must have been predominantly English...". Bodkin was writing at a time (1920) when critics were understandably anxious to discover (or even invent) an "Irish school" and Osborne did not fit into the category, even though Bodkin admired him and was one of the first critics to do him justice. Yet Osborne is in fact quintessen-tially Anglo-Irish, or Irish Protestant if you prefer; the type who went to Trinity College, played rugby or cricket there, usually joined the Royal Dublin Society and often ended up an engineer or civil servant in "the colonies". It is a type which is virtually extinct nowadays, and he represents it at its best and most civilised and so sums up a vanished era.

By Osborne's time, as has been said, Irish artists tended more and more to study and work on the Continent, unlike Mulready or Maclise or Danby, who had headed almost automatically for London. Earlier, few Irish painters and sculptors had studied in Paris,

in spite of the prestige of David's Neoclassical followers, though some had gone to Rome – notably the gifted Richard Rothwell (1800-60) and the sculptor John Hogan. France was beginning to establish herself as the painterly country of Europe, a prestige which lingered until after the Second World War. France led the world in realism, in the new techniques, and in its teaching methods. The best Paris *ateliers* were world-famous, and Paris became even more of a magnet for would-be artists when, under the Third Republic, the public art schools were opened to students from abroad as well as to native French, free of charge.

Apart from the *ateliers* and academies, there were also the artist colonies where groups congregated to paint and learn, and where living generally was cheap – Barbizon, Grez-sur-Loing, Concarneau, Pont-Aven. Irish artists worked at all these places, along with Scandinavians, Englishmen and Englishwomen, Scots (Robert Louis Stevenson was at Grez for a time and met his future wife, Fanny Osborne, there), even Americans. At Grez, for instance, there were such exotics as the Swedish artist Carl Larsson, still famous for his nursery pictures, and the composer Delius and his wife Zelka also settled there. The bridge at Grez, with its distinctive arches, must be among the most painted pieces of masonry in the world. John Lavery, the Belfast-born artist who worked there in the early 1880s, tells in his memoirs how an American art dealer complimented him for his world-famous picture of that lovely Irish colleen, "Miss Bridget Gray".

Lavery (1856-1941) actually grew up in Scotland and had a hard struggle against early poverty and bad luck. Tenacious, quietly self-sufficient and rather close-mouthed, he is the very type of Scots-Irishman whom one usually associates with the Orange Order; and yet he had a Catholic background as the orphaned son of a Belfast publican. His art studies were intermittent before he got into the Académie Julian in Paris, and from there he went to Grez where, in the opinion of most critics today, his best work was done. *Under the Cherry Tree* (Ulster Museum, Belfast) is a masterpiece in the advanced *pleinairisme* of the time. In this and in several of his

other Grez paintings, Lavery shows his exceptional ability to render the suface of water, and the shimmer of light around it, and to blend accuracy with a certain intangible "atmosphere". The figures of the man, woman and child are slightly static and perhaps rather obviously posed, but another of his special strengths was the skill with which he related figure to background in an overall pictorial unity. It was a skill which served him well later in life, when he had become an enormously successful society portraitist.

This moderately advanced *pleinairiste* style, with its cool grey-green tonality, is usually traced to the influence of the short-lived French artist Bastien-Lepage, who had come into public notice first with *The Vision of Joan of Arc*. France had recently lost her Rhenish provinces to Prussia, and the picture was widely taken to have some sort of patriotic message (the artist himself came from Lorraine). Probably this has been exaggerated; Bastien-Lepage was certainly highly influential as a teacher, but his not very interesting painting would scarcely on its own have been sufficient to excite the youth of Europe. The landscapist Charles Cazin was another strong influence which is often cited, but in essence the style was eclectic – the subject matter of Millet and Corot and the Barbizon painters updated a little, cross-bred with the academic tradition of figure painting, and given a suggestion of Impressionist shimmer and light and airiness. After Grez, Lavery went back to Glasgow, his adopted city, and became one of the "Glasgow Boys" who included Guthrie, Hornel and Henry. He painted some sensitive Whistlerian portraits and his masterpiece *The Tennis Game* (Aberdeen Art Gallery), travelled a great deal, and gradually, almost inexorably, became a painter of the international rich. It may have been his contacts with the Munich School of realists which darkened his colours, but he never again achieved the clarity and airiness of his French period. Finally, in his later years he became a bravura portraitist sought out by celebrities – among those he painted were Churchill and the English Royal Family, and the great tenor John McCormack.

It was an oddity that Lavery, who seems to have had very little

national feeling, should have become the painter to record key incidents in the Irish Civil War. He had married, as his second wife, a beautiful young American, Hazel Martyn, who appears often in his late work and for years was a familiar face on Irish banknotes. Hazel seems to have loved the high life, but she also became emotionally involved in the Irish Civil War and was an ardent admirer of Michael Collins. When Collins was tragically shot in an ambush in 1922, Lavery painted him lying in state beneath the Tricolour with the words "Love for Ireland" on the upper right – a simple, moving picture, if not an actual masterpiece. Lavery's touch coarsened a good deal in the last quarter of his long life, and by the time of his death in Kilkenny (where he was marooned by the Second World War) he was a figure of the past. Ironically, the beautiful Hazel had predeceased him.

Another Irish artist to work at Grez was Frank O'Meara (1853-88), who peopled outwardly straightforward, beautifully observed land-scapes with rather symbolist or allegorical figures which have a *fin de siècle* tinge – *Towards Night and Winter* (Hugh Lane Muncipal Gallery, Dublin) is typical of his style. O'Meara produced relatively little before he came back to his native Carlow to die of malaria at thirty-five; but his pictures have a very individual mood: melan-choly, autumnal and introspective – the mood of Yeats's early poetry, particularly *The Wind in the Reeds*. O'Meara, however, anticipated Yeats by several years, so in a sense he can claim to be the first figure of the "Celtic Twilight" – a fact which has been very little recognised.

Helen Mabel Trevor (1831-1900), from County Down, worked for periods in Brittany and ended by settling in Paris for the rest of her life. Many of her works are scenes from peasant life, and her style is more robust and less consciously poetic than O'Meara's, but also less original. Egerton Bushe Coghill, cousin and brother-in-law of the novelist Edith Somerville who herself studied art in France, painted in and around Barbizon and was associated with the New English Arts Club in London before returning to his native County Cork; he is a fine landscapist whose work is difficult to

Landscape near Castletownshend by Egerton Bushe Coghill (1903). He studied in France like so many Irish painters of his generation.

trace in quantity, though enough of it was available to merit a well-received show in a London gallery in the 1960s.

A man rather apart from this outwardly advanced, inwardly conservative Realism is Roderic O'Conor (1860-1940), whose ultimate place in Irish art and art in general has been debated more intensely in the last decade than that of almost any other Irish painter. A man with a "landed" background, related to the ancient family of O'Connor Don, he studied successively in Dublin, Antwerp (like Osborne, Norman Garstin, Malachy Kavanagh and other Irishmen) and then in Paris, under the society portraitist Carolus-Duran. Almost inevitably, he too worked at Grez for a time and then in Brittany, becoming one of Gauguin's intimate circle at Pont-Aven. This was the most significant chapter in his life; Gauguin is said to have urged him to come with him to the South Seas, but he refused. For the rest of his long life O'Conor lived in Paris, married a much younger Frenchwoman, and became a figure in quasi-Bohemian circles. Visiting English writers and artists made a point of looking him up, including the critic Clive Bell. He is sometimes claimed to have had a major influence on the English painter Matthew Smith, and he also met Somerset Maugham, who disliked him – it was mutual – and put him into his novel *The Moon and Sixpence*. O'Conor was a connoisseur and a highly cultured man who remained alert all his life to current trends in art and literature, and he seems to have had enough money to collect pictures in a modest way. His personality, in fact, seems to have been a powerful one, though he shunned publicity rather than sought it, and was sometimes rude to people who searched him out.

Major claims are regularly made for him nowadays, and to come across one or two of his finest pictures in isolation can make you feel you are in the presence of a major artist, without qualification. No Irish painter of the time promises more; here at last, you feel, is the missing link, the unique Irishman who bridges the gap between Realism and Post-Impressionism. Yet to see him in bulk is often an anti-climax, relatively speaking, and it is hard, if not impossible, to trace a line of continuity or development through

his strangely varied and uneven output. Some of his painting is relatively traditional and straightforwardly realistic; some shows the influences of Gauguin and Van Gogh; some of it even anticipates Fauvism – but the unifying core of personality is often elusive, if ultimately it does exist at all. The nudes suggest late Renoir, the seascapes tend to resemble Monet's, the still-life paintings often have a whiff of Cézanne, through the brushwork and heavy, often blunt forms, and the reddish, rather "hot" tones are unmistakably O'Conor's own. No one represents more thoroughly the intelligent *emigré* artist, on the edge of great events and responding to them feverishly.

He is hung in the Tate Gallery, and the National Gallery of Ireland's *La Ferme de Lezaven*, painted near Finistère, shows him at his very best, taking the influence of Gauguin and the Nabis in his stride without adulteration of his own curious mentality. Perhaps the still-life and flower pieces are ultimately the most satisfying and consistent area of his output, showing a fine, meaty feeling for pigment, rich yet well-modulated colours, and an inborn ability to place objects in light and space. But O'Conor seems to have been one of those relatively overcultured men who are almost too impressionable and responsive for their own good, too easily stamped with the imprint of personalities stronger and more unified than their own. In the long run, his place probably lies closer to the secondary Post-Impressionists, such as Angrand, Manguin, Anquetin, Russell and Emile Bernard, than it does to the great innovators at the apex of the pyramid. Yet his is a compelling figure in his own right, both artistically and biographically.

Irishmen also worked at the *pleinairiste* centres in Brittany, among them Norman Garstin (1847-1926), who like Hone had begun life as an engineer and took up painting rather late after an adventurous early life which included diamond-prospecting in South Africa. He studied in Antwerp, like Osborne and Malachy Kavanagh, then under Carolus-Duran in Paris, painted in Brittany as has been mentioned, and finally settled at Newlyn in Cornwall, then already beginning to take shape as an art colony. The Newlyn School has had

a considerable revival in England recently, and essentially it was the new French outdoor realism translated into Cornish, a world very similar to Brittany, except that chapel-going Methodists supplanted the piously Catholic Bretons. Garstin is a gifted but rather uneven painter, more at ease on the whole with intimate, domestic subjects than he was with the hardy, ultra-masculine milieu of fishermen and farmers he settled into. He is temperamentally much closer to, say, Osborne than he is to his colleague Stanhope Forbes (1857-1947), the central figure of the Newlyn School.

Since he was born in Dublin, Forbes can be counted as some sort of Irishman, though his father was an English railway official living in Ireland, and his mother was French. He is perhaps the greatest of Irish and English Realist painters of the time, even including the leading figures in the New English Arts Club which represented the advanced, rather Frenchified wing of British art and with which Garstin had links (so too had Osborne and Coghill). *The Health of the Bride* (Tate Gallery) has been called the last of the great Victorian genre paintings, but it is actually a classic of Franco-British Realism, and the people in it were local Newlyn folk, a common custom with the Newlyn painters who either did not have professional models or could not afford them, and in any case preferred to paint from "real" life. *Plenairisme* was, of course, fanatically open-air in its tenets, but the shadow of the studio often lies heavily on it and the poses sometimes look too obviously "life-class", without the artfully casual look of Impressionism. Forbes' finest picture is probably *A Fish Sale on a Cornish Beach* (1885) at Plymouth, and in the Walker Art Gallery in Liverpool there is another out of doors masterpiece, *Off to the Fishing Grounds*, which shows what gifts he had for painting the sea and boats. He had the rare, inborn talent for figure painting on a large scale, and there is a sculptural, almost heroic solidity and monumentality about his best work which separates it from most of his contemporaries, who were genre painters at heart. Forbes married a talented Canadian painter, Elizabeth Armstrong, whose death in 1917, together with the death of their only son in the Great War, was something from

which he never recovered. His later work lacks the weightiness and strength of his early period, and he lived to become a reactionary against Modernist trends, when Cornwall was invaded by Ben Nicholson and other standard-bearers of a new culture.

Joseph Malachy Kavanagh (1856-1918) studied in Antwerp with Osborne and even shared lodgings with him there for a time. Kavanagh is a real *petit-maître*, lovingly sought after by collectors, even if he has made no real niche in art histories. He is hardly a *pleinairiste* at all; in fact, the main influences on him were Belgian and Dutch and his tones are darker than those of the painters who worked in Grez or Concarneau. Kavanagh's scale is usually rather small and his subjects are intimate and homely, often nostalgic – an old back street with a few simple folk, an avenue of trees, a few diminutive figures on a wet beach. He really belongs with Mauve and Maris and The Hague School, and, like them, he had an inborn painterliness which could make a perfect, lyrical canvas out of banal or hackneyed subject matter. Kavanagh's last years were darkened by the destruction of a batch of his works in the 1916 Rising in Dublin, when the RHA building was shelled and set on fire. In a way, this episode symbolises the end of an entire epoch, not only in diminutive Ireland, but all over Europe.

And, in a very different background and mileu, there is George William Joy (1844-1925), whose only link with the painters discussed is that he too studied in France – in Paris under Jalabert, a pupil of Delaroche. A versatile painter, at times little better than a competent journeyman, he exhibited regularly at the Royal Academy and in 1881 caused a minor stir with his *Joan of Arc*, which was sold on the opening day of the Academy. Today Joy is mainly remembered for a single painting, *The Bayswater Omnibus* (London Museum), a genre piece of great charm and style which is often reproduced and which is like a magic window into the life of London in the "gay nineties" (members of his own family posed for it).

Patrick Vincent Duffy (1832-1904), by contrast, seems hardly to have been outside Ireland in his life, and his career was closely

Old Convent Gate, Dinan by Joseph Malachy Kavanagh (1883). Unlike most Irish artists who studied on the Continent, Kavanagh is closer to Dutch and Belgian art than he is to the French school.

bound up with the Royal Hibernian Academy, of which he became Keeper (like Kavanagh), though he also exhibited in London. At one stage he was close to the talented landscapist John Faulkner (1830-88), who was expelled from the RHA for some still-obscure scandal and who lived later in America and London. In spite of his quiet and insular life, Duffy's landscapes are surprisingly free and airy for their time and milieu, with a feeling for wide, almost empty spaces which is remarkably close to some of the Barbizon artists. They lack just that final intensity and concentration which is one of the hallmarks of genuinely great art.

4

The New Century

THE IRISH art context of the nineteenth century is in ways a microcosm of the national life – a general ferment and a quest for identity or self-realisation, contrasted with a huge dispersion of energies and a flow of the finest talents overseas. Just as the Great Famine set in motion the floodtide of emigration which continues into this century, so the better Irish brains and talents in art, literature and science were often directed abroad. Many of them, of course, returned, like Hone and Osborne; others, including Maclise, Danby, O'Conor and Garstin, were lost to their homeland for good, while others again, such as Lavery, maintained a dubious and ambivalent relationship with it. As with the hordes of emigrants who took ship for America and Canada and Australia, it was often the more enterprising and gifted who left, while the mediocrities remained behind and impressed themselves on a relatively provincial, unsophisticated public.

Some of the blame for this must go to the Royal Hibernian Academy which held a virtual stranglehold over art in Dublin, where there were few exhibition venues and indeed relatively few exhibitions of any kind. As mentioned earlier, Ireland never developed the kind of *nouveau-riche* patron who in Britain had gradually taken over from the old-style aristocratic one – the kind which enabled Rossetti, for instance, to go on painting and selling without benefit of the Royal Academy. The RHA did not shout down the major

talents – it had just sense enough to know that it needed them – but all the evidence is that the average Irish academician was mediocre and careerist, as well as unimaginative – in fact, often little more than a skilled tradesman intent on establishing what nowadays would be called a closed shop. Commercial portraiture, sentimental or humorous genre, laboured antiquarianism, conventionally picturesque landscape, made up the staple fare of the annual RHA exhibitions. Its members never took on with any real conviction or authority the role of forming or educating public taste, as the great RA personalities did in England. Even Old Masters were not easy to see, and the National Gallery of Ireland only took shape near the end of the 1860s.

The revival in Irish art and crafts was to a great extent the work of a remarkable impresario, organiser and enthusiast, Hugh Lane. Lane was born in County Cork in 1875, the son of a clergyman whose wife was a sister of Lady Gregory, the hostess and mother-figure of the Literary Revival. The couple were estranged and in the end virtually separated, so that Lane was brought up by his semi-nomadic mother who taught him French and how to play the piano, but very little else. (He never quite learned to write English and in spite of his very public career, he hardly ever spoke in public.) It was Lady Gregory who, with her usual practical and social flair, got him his *entrée* into art-dealing circles. He in turn found that he had a flair for the profession and was rich and successful before he had turned thirty.

In the first year of the twentieth century, Lane arrived at a house-party in Coole, Lady Gregory's home near Gort in County Galway, and found himself a fellow-guest with W.B. Yeats, the playwright Edward Martyn who lived nearby, Douglas Hyde the energiser of the Gaelic League, and various other literary and intellectual lions. The rather foppish young London art-dealer did not fit in very well in this company, but he plainly listened and learned. Later the same year, he visited an exhibition in Dublin by two grand old men of Irish painting, Nathaniel Hone and the portraitist John Butler Yeats, who were revered inside a limited circle but made little appeal to

the wider public. Lane at this time was not greatly drawn to art outside the Old Masters he dealt in, but he seems to have caught fire at once, since he bought two of Hone's pictures and commissioned from John B Yeats, a series of portraits of distinguished Irishmen. Yeats, typically, never got far with the project and eventually Orpen was called in to complete it.

A little later, Lane won the good will of the stodgy, rather suspicious RHA by organising on its premises an exhibition of Old Master paintings from Irish private collections. It was a big success financially, artistically and socially, so he then could draw the RHA into supporting his campaign for a gallery of modern art in Dublin. His next step was to organise an epochal exhibition of works by Irish painters in the Guildhall in London, which opened in May 1904. It contained nearly 500 works, and all the great names were represented: Hone, Osborne, Lavery, the young Jack Yeats (then only a watercolour painter) and Orpen. Lane even roped in that social lion of the 1890s, Charles Shannon, on the grounds that he had an Irish grandfather. Over three-quarters of a century later, this exhibition remains unique, a landmark – the one and only attempt on a really large scale to show that Ireland has a painterly tradition as well as a literary one.

The next few years were spent by Lane in a multi-tentacled campaign to make his idea of a modern art gallery for Dublin into a reality. Political support was lobbied at home and in London; many people, from King George V (who promised two Corots and two Constables) to the renegade American racketeer "Boss" Croker, came forward with gifts or promises; living artists were approached for loans or gifts. Even President Theodore Roosevelt wrote from America, enclosing a subscription. Lane had a genius for publicity, for flattering the rich and famous and for handling press relations, as well as an almost monomaniac tenacity in pursuit of any goal he set for himself. Finally, the new Dublin Municipal Gallery of Modern Art opened on Harcourt Street in January 1908. (It has since moved to Charlemont House, an eighteenth-century Georgian mansion on the north side of the Liffey.)

The collection included works by Constable, Corot, Manet, Courbet, Monticelli, Burne-Jones, Puvis de Chavannes, Daumier, Degas, Millet, Boldini, Pissarro, Renoir, Rousseau, Sickert, Alfred Stevens, Stott of Oldham, Vuillard, Whistler, Mauve, Mesdag; sculptures by Rodin, Maillol and the Irishman John Hughes; and among the Irish painters included were Yeats *père et fils*, Hone, Osborne, Orpen, Lavery, and (if his Irishness will pass) Charles Shannon. Ambrose McEvoy was another ambiguous case, since he was of English birth but Irish parentage. Augustus John was listed among the British names. Lane himself had been particularly generous with his gifts and purchases. He was still a learner in the field of modern art – up to a few years previously, his taste does not seem to have got much further than that long-lived eminent Victorian G.F. Watts – but he took advice from his friend Orpen, whose moderately advanced views went as far as accepting Impressionism.

In his preface to the catalogue for the gallery, Lane ended by saying that "its influence must necessarily show itself in the next generation of artists, and of their critics. The opponents of the gallery have been those who have not had the advantage of the study of these modern classics abroad, and who naturally cannot accept a standard of taste so different from that which they have hitherto recognised." This was certainly throwing down the gauntlet to the philistines and the conservatives, and he must have known it, but according to his admirer Thomas Bodkin (later director of the National Gallery of Ireland) in his book *Huge Lane and His Pictures*, Lane did not grasp how many enemies he had made or was making, or the whispering campaign being conducted against him. He went on to acquire a knighthood and to spend some of his astonishing energy – George Moore remarks that he was "always in a hurry" – on setting up a public art gallery in Cape Town. Meanwhile, he was constantly adding to the collection of his love-child, the Dublin gallery.

The Harcourt Street premises had never been anything more than a stopgap affair, so Lane badgered Dublin Corporation continually

to provide a permanent site and building. A proposal to build a gallery in St Stephen's Green was vetoed by Lord Ardilaun, the Viceroy, and meanwhile Lane threatened to withdraw the pictures he had given as a "conditional gift" or loan if the matter was not settled. Opposition to him was growing steadily, even if most of it was underhand or behind the scenes. Some saw him as a London interloper bullying Dublin for his own glory, others viewed him as frankly a dealer on the make, and the more conservative artists – who were many – resented his patronage of a type of art they could not and would not understand, and by which they felt threatened. In 1913 the Corporation voted £25,000 towards the cost of the new gallery, with a supplementary £3,000. The eminent architect Lutyens drew up plans for a riverside gallery consisting of two wings linked by a bridge over the Liffey, and Lane threw his weight and energy behind the scheme, but eventually it was rejected. Lane carried out his threat by removing his "conditional gift" of thirty-nine works by continental artists and some British ones, and £11,000 raised by public subscription was returned to the subcribers. So ended the first chapter in the history of the so-called Lane Pictures, which bedevilled Anglo-Irish relations for more than forty years.

The tradition that Lane left Ireland in a huff is pure myth, and is a misreading of his imperious character. All the signs are that his gesture was part of his overall strategy, and he did not give up his directorship of the Dublin gallery. In fact, the following year he was elected director of the National Gallery of Ireland by a large majority, a sure proof that he still had a strong following in Dublin, and he took his duties very seriously, enriching the gallery's collection with various Old Master pictures of his own. Meanwhile, he had been courted in London, where approaches were made to him to lend the pictures he had withdrawn to the National Gallery or the Tate. (The Tate was not then an independent institution but was usually referred to as "The National Gallery, Millbank".) Eventually he did so, the offer was accepted, and Lane made a new will making various bequests to both public galleries

in Dublin and left what were later called the "Lane Pictures" to found a "collection of Modern Continental Art" in London.

As it turned out, the London art authorities were no more enlightened than the Dublin ones – in fact, rather less so. They repudiated their previous agreement and decided to accept only fifteen of the thirty-nine pictures offered, with works by Monet, Renoir and Daumier among the *réfusés*. Lane naturally was furious, but his energies were now temporarily diverted by his director-ship of the National Gallery of Ireland. In February 1915, before leaving reluctantly for America where he was to appear as a key witness in a lawsuit, he added a codicil to his recent will (there had been a previous one) bequeathing the controversial pictures to the city of Dublin, "providing that a suitable building is provided for them within five years of my death". If this condition was not met, the pictures were to be sold.

Lane, who detested lawyers and legal matters, did not have the codicil witnessed. The rest is history: on his return journey to Ireland, he was torpedoed on the *Lusitania* and was last seen help-ing women and children into lifeboats. London did not return the Lane Pictures, and one of the most vitriolic and involved controver-sies of the century raged for many years, with W.B. Yeats in the chief tenor part for Ireland and D.S. McColl of the Tate Gallery leading the bass choir of the powerful opposition. It was not until 1960 that the present arrangement was made by which the collec-tion alternates between Dublin and London – an agreement which might not have been reached if two Irish students had not walked off with Berthe Morisot's *Jour d'Été* from the Tate, under the pretence that they were copying it.

This incident has been described at length not only because of its inherent celebrity interest and the passions it awakened for decades, but because it appeared symptomatic of the artistic values of the time. Impressionism was still a foreign body, in London as well as in Ireland, though the more intelligent private collectors had been buying the Impressionists for years. (In Paris, a similar controversy took place over the Caillebotte Legacy to the Louvre.)

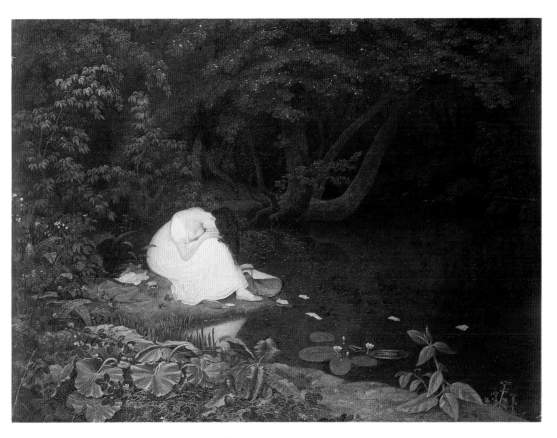

Disappointed Love by Francis Danby (*c.* 1821). Lovingly detailed, this picture anticipates the Pre-Raphaelite movement.

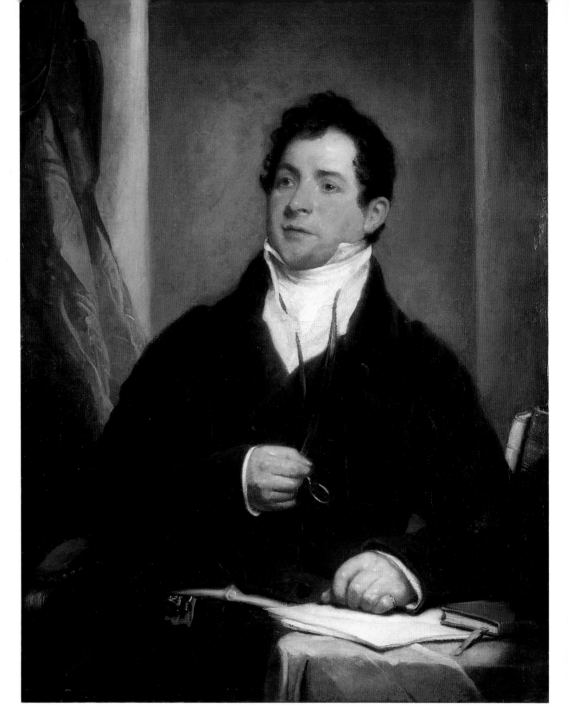

Portrait of Thomas Moore by Sir William Archer Shee (*c.* 1820).

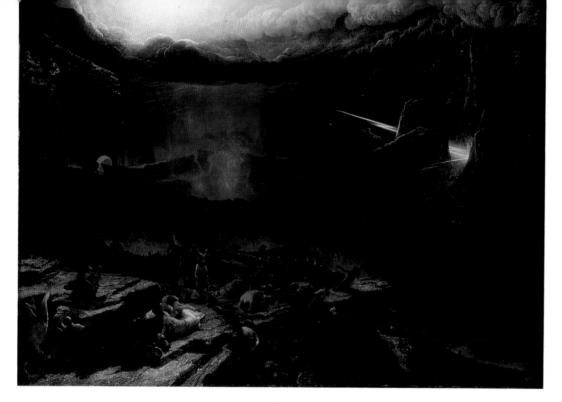

The Opening of the Sixth Seal by Francis Danby (1828). The apocalyptic imagery and use of lurid colour, show Danby at the height of his powers.

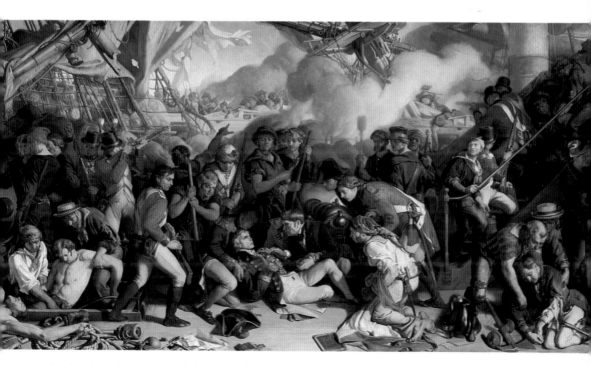

The Death of Nelson (detail) by Daniel Maclise (1866). Originally exhibited at the Royal Academy under the title "Here Nelson Fell", this was a study for the massive mural in the House of Lords at Westminster.

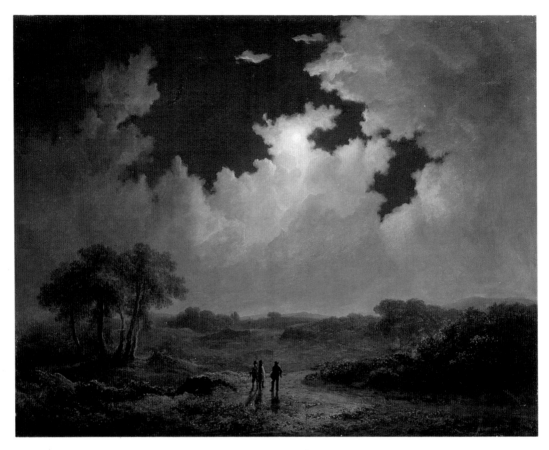

The Poachers by James Arthur O'Connor (1835).

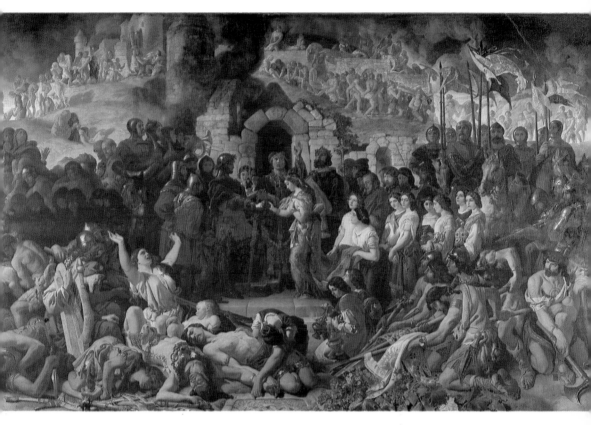

The Marriage of Princess Aoife and the Earl of Pembroke (Strongbow) by Daniel Maclise (1854). This massive canvas shows Maclise's closeness to the "history painting" schools of France and Germany.

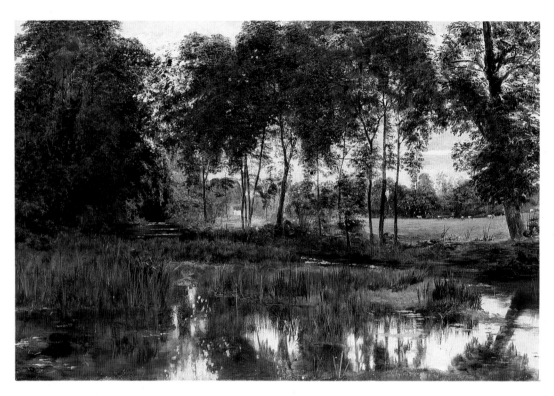

The Rye Water Near Leixlip by William Davis (*c.* 1860). Davis's combination of precise detail and poetic reverie is reminiscent of the Pre-Raphaelites.

In the Phoenix Park; Light and Shade by Walter Osborne (*c.* 1885). Osborne's humanity and powers of sympathy are plain in his pictures of the poor. .

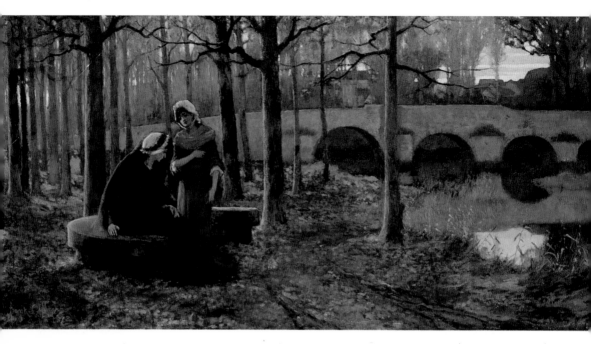

Autumnal Sorrows by Frank O'Meara (1878). The mood of melancholy and approaching winter is typical of O'Meara who died of malarial fever at the age of thirty-five.

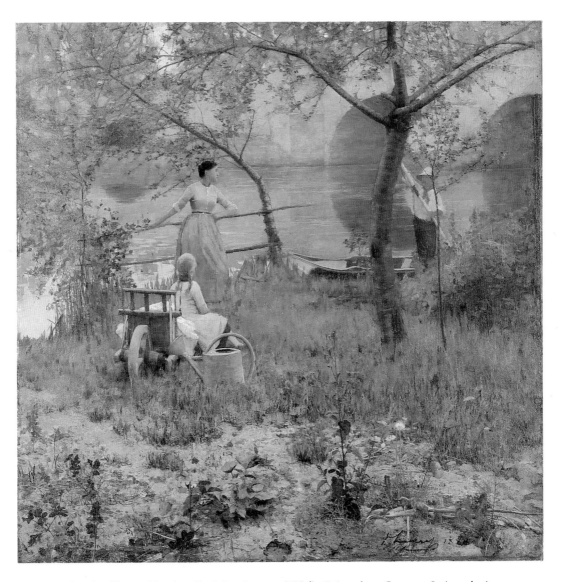

Under the Cherry Tree by Sir John Lavery (1884). Painted at Grez-sur-Loing during Lavery's French period, when much of his best work was created.

George Moore by John Butler Yeats (*c.*1902). Yeats left an entire portrait gallery of the leading figures of the Literary Revival.

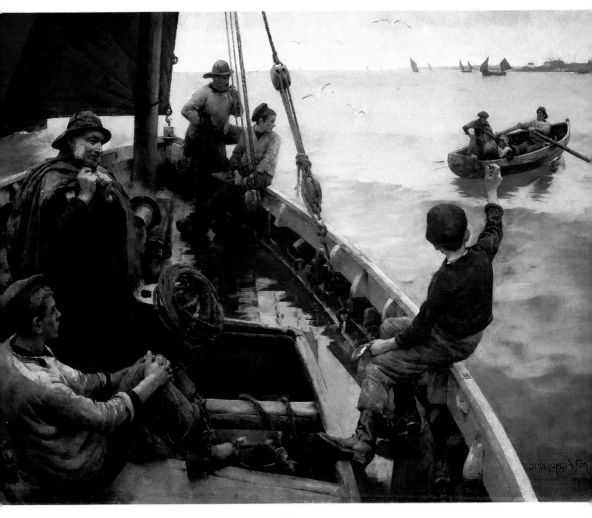

Off to the Fishing Grounds by Stanhope Forbes (1886). Though born in Dublin, Forbes spent most of his active career in France and Britain, becoming the leading figure in the Newlyn School.

Shades of Evening by Mildred Anne Butler (1904).

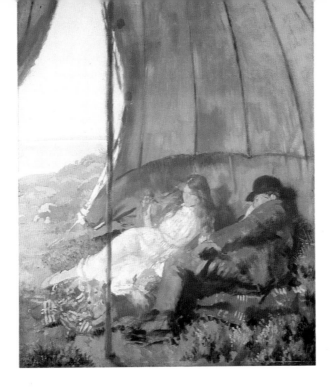

Looking Out to Sea by William Orpen (*c.* 1912). The setting is Howth Head, to the north of Dublin, and the people shown are probably Orpen and his wife, Grace Knewstub.

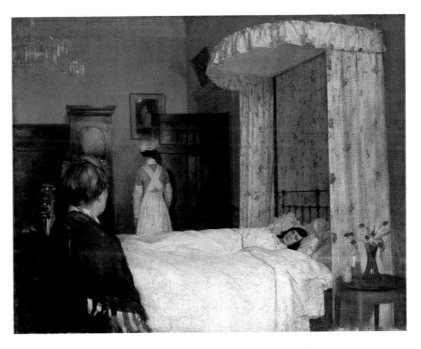

The Doctor's Visit by Leo Whelan (1916). Whelan was best known for his portraits, but genre pieces such as this reveal a more sensitive aspect of Irish academic art.

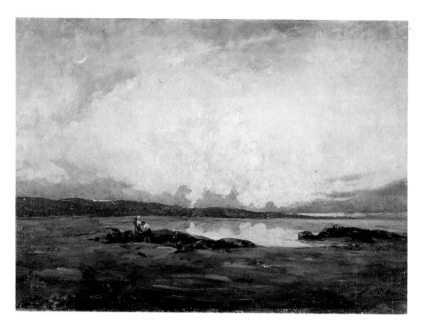

Evening Malahide Sands by Nathaniel Hone the Younger (1910). This austere, brooding tonal symphony reveals Hone's earlier apprenticeship to the Barbizon painters in France.

Reclining Nude Before a Mirror by Roderic O'Conor (1909). O'Conor's long years of voluntary exile in France are reflected in this painting, with its characteristically warm tone.

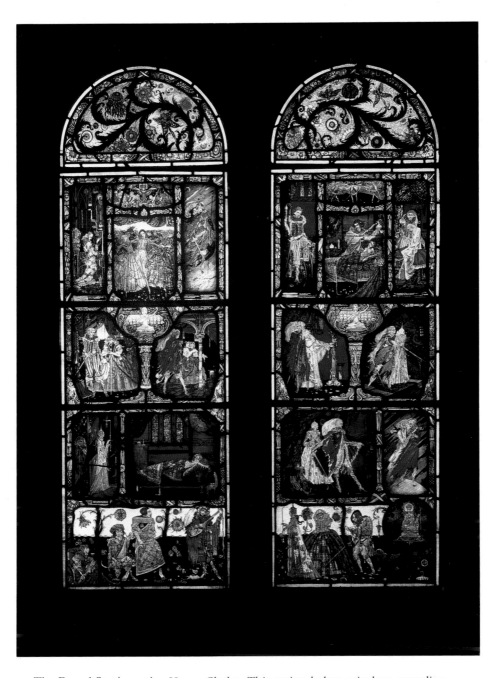

The Eve of St. Agnes by Harry Clarke. This stained-glass window, revealing Clarke's debt to Aubrey Beardsley and Art Nouveau, won a gold trophy at the Aonach Tailteann in Dublin in 1924.

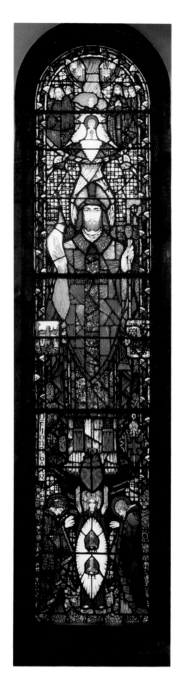
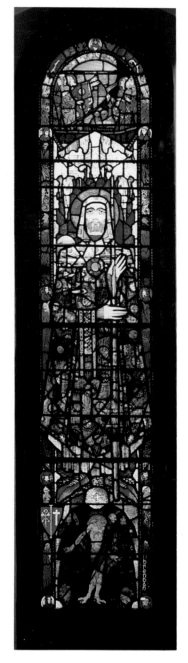

Memorial Windows, (Honan Chapel, University College Cork) by
Harry Clarke (1915-17). These monumental figures of Irish
saints show the austere power of Clarke's early masterpiece.

The Fate of the Children of Lir by Wilhelmina Geddes (1917). These eight stained-glass
panels represent a rare attempt to depict themes from Irish mythology.

Yet by the time Lane went down on the *Lusitania*, Cubism and Fauvism were already past their apex, Expressionism was conquering Germany, and abstract art had already been pioneered by Malevich, Kupka and others. Once again, a huge gap had opened up between the recognition of the intelligent few, the indifference of the public, and the dogmatism of entrenched art officialdom.

In terms of historical amends, it is good at least to record that the present modern gallery in Charlemont House is now officially named the "Hugh Lane Municipal Gallery", and that its founder has been fully vindicated by history. The original rebuff to Lane can be seen now as more a matter of bureaucratic ineptitude and green tape by Dublin Corporation, than of actual philistinism or conservative intrigues, though the unpleasant whispering campaign against him may have influenced certain people (there was also, apparently, some chauvinistic hostility to Lutyens as a non-Irish architect). In W.B. Yeats's phrase, Ireland had "disgraced itself again", even if it was not alone in doing so.

5

The Gold and Silver Age

THE LANE collection controversy became tiresome and even petty in many of its manifestations. It is one of those episodes from which few figures came out with credit, and some of the mutual recriminations and innuendoes make depressing reading for those who still want to read them today. Note, for instance, the curious mixture of top-loftical rhetoric and personalised spleen which marks most of W.B. Yeats's writings on the subject, either in prose or verse. Yet the overall effect, in spite of the loss of the pictures to Ireland for decades, was to raise art consciousness in the country and to draw Irish writers and artists together more in the face of what many of them – leaving out Dublin philistinism – saw as British duplicity and acquisitiveness, or simply as arrogance and cultural colonialism. At its worst, this took the form of that familiar national vice, the tendency to nurse a grievance and do nothing positive to better things. The positive side, however, was to give extra impetus to the cultural upsurge which was already expressing itself through the Literary Revival, and to keep alive the enthusiasm which Lane had done so much to arouse. The first two decades of the century were in fact a golden age for Irish art, even if it has never quite permeated through to the mass of people as the Literary Revival did.

To a remarkable extent, the literary and art revivals go together and certainly they were closely interlinked. There were several reasons for this, and nearly all of them hinge on individuals, rather

than on circumstances or trends. The first was the fact that Lane was a nephew of Lady Gregory and through her enlisted the backing of influential, or at least highly vocal, leading literary men and intellectuals. The second was the return to Dublin for a time of George Moore, who was both an established Realist novelist and a propagandist for the French Impressionists, whom he had known in Paris years before (it is true that modern scholarship has picked holes in his account of those years, but he did undoubtedly meet most of them and his writings helped to spread knowledge of their work in England). As a quondam painter himself, Moore understood contemporary painting in a way few writers did, and was as much at home among artists as he was with writers – more so, in fact, since with the painters he could throw off his offensive-defensive armour and lose the edgy competitiveness which was part of his curious, ultra-complex and often contradictory personality.

The third major factor was the Yeats family, a unique triumvirate of painter-father, painter-son and poet-son. Apart from being probably the finest portraitist of his time in the English-speaking world, with the exception of Sargent, John Butler Yeats was a man of great culture, charm and personal magnetism. In fact, the memory of his conversation and his enormous responsiveness and ability to draw out the best in people, both personally and creatively, was so potent long after his death that it overshadowed his work. His natural gifts as a painter were rarely questioned, but he was often written off as something of a Micawber figure, living in a perpetual dream-world of optimism while evading the demands of the present. It was said that he could hardly bear to finish a picture, that he lacked technique, could not paint hands and bodies as well as he could paint faces, and that he could rarely get a good likeness. It is particularly sad that this type of more-in-sorrow-than-in-anger denigration came from some of those who were fondest of him personally.

Yeats (1839-1922) might have agreed with many of his critics, since he totally lacked self-confidence – partly, perhaps, the result of rather a late start as an artist after attempting a law career. His

early decades as a practising artist were spent in London, where he came close to the dying embers of Pre-Raphaelitism and was also a friend of the very gifted genre painter Frank Potter (unsuccessful in his lifetime, but now hung in the Tate). Yeats tried his hand at Pre-Raphaelite subjects, and also painted some street scenes and genre works which are close to Osborne's, though less accomplished (*The Bird Market*, National Gallery of Ireland), but his natural bent was for portraiture. Since he was utterly unbusinesslike, he failed to make a steady income out of this and the Yeats household in London was darkened with genteel, rather bohemian poverty, complicated by the fact that his wife suffered a stroke which left her a semi-invalid. He always had a circle of friends, both literary and painterly, who believed in him and tried to help him along, but he was of that chronic type which can neither push nor be pushed. Those who tried included the eternal organiser and fairy godmother Lady Gregory whom he seems rather to have disliked, and of course Lane, who commissioned him to paint the series of portraits mentioned in the previous chapter.

Yeats tended to alternate between a kind of feckless serenity and a corrosive anxiety and self-doubt which made him duck many commissions, spoil some fine pictures by continual, compulsive retouching, and leave others unfinished. Two things might have altered his life radically – a strong, capable, managing wife who would have eased his family worries and hunted up clients, or a completely bohemian existence without family and other ties. In fact, his old age in New York came close to the latter category, where he lived in a boarding house, painted and sketched as the mood took him, did some writing and journalism, formed friendships with writers and *avant-garde* artists often generations younger than himself, and attracted people of all sorts and ages to hear his conversation. It should be remembered, however, that in New York he was protected by the friendship and patronage of the great Irish-American lawyer and art collector John Quinn.

One of the chief reasons why he did not succeed socially and financially as a portraitist is that he rarely painted people to whom

Maud Gonne MacBride by John Butier Yeats (1907).

Portrait of Isaac Butt by John Butler Yeats (1870). Yeats was a personal friend and admirer of this Irish statesman.

he did not respond personally or even intimately, and even then he could rarely let well enough alone. His rubbings-out and *pentimenti* have become notorious, though even this trait is preferable to the mechanical, impersonal competence and gloss which Sargent and Orpen brought to many of their commissions. Yet this superficially amateur slowness was also a source of strength, since there is a depth of humanity and psychological insight in his work which is almost Rembrandtesque. Yeats was mentally a late Victorian, with the gravity and psychological curiosity of late Victorian art and literature, though he was extremely open-minded about developments in art right into old age. He was never remotely a virtuoso like Sargent or a "pure" painter like Manet, and as a colourist he was limited and sometimes timid. His special power is to make you feel that you are face to face and alone with the people he paints, including the melancholy, ashen-faced Synge, the distinguished, keen-eyed, sarcastic Moore, and other notables of the Literary Revival, both first and second-rate, including his own family. Yeats, in short, is *the* portraitist of the Irish Renaissance and has left a whole picture-gallery of its leading figures and types. It is a privilege which few literary movements have enjoyed. G.F. Watts did the same for England's Victorian intelligentsia, yet his handling is woolly beside the Irishman's.

Generally his poses are simple and informal (nothing full-dress or ceremonial, as in Sargent), and there are few accessories or props, though Yeats knew how to bring out an eloquent detail or a highlight with small, telling touches of local colour. Few of his portraits are more than half-length or three-quarter length. Much of the expression comes from the treatment of the eyes, and he has been criticised for slurring over the hands of his sitters or of letting their bodies taper off limply and inconclusively. Yet this has the effect of highlighting the sitters' faces, which is Yeats's chief interest, and it is when he tries for too much overall "finish" that he sometimes loses his way. He seems to have had a special feeling for women, whom he paints with rare insight and sensitivity, though he also has that special Victorian ability to bring out the

intellectual distinction of his male sitters – whose intellectual equal, in any case, he was by right. Like Hone's, his tonality is often rather muted or greyish, but he is capable of surprising subtleties within his range. Colour apart, Yeats was a superb black-and-white draughtsman, perhaps the finest in twentieth-century Irish art, and his many thousands of pencil sketches contain so many perfect vignettes of the life around him that it becomes almost impossible to single any out.

If Hone and Osborne are often coupled historically, so are Yeats and his much younger compatriot and sometimes rival, William Orpen (1878-1931). In reality they have nothing in common except the fact that they painted portraits; they are indeed total opposites, like W.B. Yeats and George Moore. Yeats is known to have admired Orpen's gifts ("he has a great future", he wrote in *Letters to His Son*) though is it not recorded what Orpen thought of Yeats, if indeed he seriously considered him at all. Yeats, in spite of his submersion in English art, literature and thought, was defiantly nationalist, while Orpen was the paradigm of the "West Brit", the Irishman who looks to England for his models in virtually every field. Curiously but not untypically, Orpen often chafed against the English character in London, finding it stolid, smug and rather boring.

Yeats was as quietly and unspectacularly unsuccessful as Orpen was spectacularly rich and famous and sought after; and while Yeats took up full-time painting rather late, Orpen was a schoolboy prodigy and an art-school prizewinner. Orpen painted the rich, the famous and the internationally glamorous, while Yeats preferred to portray his family, his friends and his intellectual equals with no reference to their social status or worldly celebrity. Finally, Yeats failed utterly to dominate his life circumstances and to come to terms with the hard realities of money, fame and social advancement, while Orpen seemed to handle all these things like a virtuoso juggler keeping skittles in the air. Yet Yeats's stock has increased steadily, though slowly, since his death, while Orpen's one-time world fame went to shreds and tatters not long after his death. Until the recent revival of interest in him (to a great extent,

the result of Bruce Arnold's excellent biography *Orpen: Mirror of an Age*), his posthumous reputation suffered precisely from what made him successful in his lifetime: his portraits, by which he is still too often judged. In fact, portraiture is only a single facet of Orpen's large output, and many, or even most, of his best achievements are in other areas; like Lavery, he did most of his finest work young. From the start he was a virtuoso draughtsman and he soon developed into a virtuoso user of paint, though there is sometimes a curious insensitivity about his handling, as well as a tonal coarseness which he never entirely got rid of.

He is not at all an easy artist to do full justice to, as is so often the case with those men who belong completely to their age, and so rise and fall with it. Orpen was essentially an international eclectic of the type thrown up in many countries during the *Belle Époque* – Sorolla in Spain, Liebermann in Germany, Mancini in Italy, Zorn in Sweden. At the time their style appeared novel and daring, if not revolutionary, but it can now be seen as essentially late Realist, energised and brightened by Impressionist light effects and by the broad, eloquent, virtuoso brushwork of Manet. It was in fact the last of the Old World, the Old Order, not the start of the new, and it is significant that after the First World War Orpen soon became virtually a reactionary and an opponent of Modernism. His world had crumbled, though he could not and would not admit it, and it was ultimately unfortunate for Irish art that the influence of his teaching and his incisive, high-powered personality lasted so long and went so deep.

Orpen needs, above all, care and discrimination in singling out his sincere, spontaneously felt paintings from the mass of meretricious or inferior work he produced. At heart, he was more interested in painting figures in an expressive setting than in depicting single, face-to-face personalities, though the magnificent full-length portrait of his close friend Mrs St George rivals Sargent on his own ground. The warm, almost luxurious intimacy of his peopled interiors, his groups of men and women on sunlit beaches, the flair for large-scale design shown in his familiar set piece *Homage*

Oliver Sheppard by William Orpen (1907). Sheppard was a leading Irish sculptor.

to Manet (Manchester Art Gallery) and in which the sitters include George Moore and Wilson Steer – these are all living facets of his work which have survived the ups-and-downs of fashion and the marches or counter-marches of movements. If Orpen is not quite an artist of the first rank, he is certainly high up in the second class and a more fulfilled one than his contemporary and friend Augustus John, who probably had more innate or potential genius. With the passing of time, too, certain pictures of his which once seemed daringly modern, then later brash and vulgar, now have acquired a patina of historical and social nostalgia, giving them an extra dimension of emotional depth. We can now see the sumptuous upper-class life of the years before the First World War – that watershed for the West – portrayed lovingly in his work, and we can forget the epoch's frequent vulgarity and hollowness, and admire its style and its opulence of texture. Orpen, in effect, has become a social historian of his epoch, in paint and canvas, just as Proust and Henry James portrayed their milieu in words; though unlike them, he stood too close to that world to be able to criticise or anatomise it.

In fairness, too, it should be remembered that at the peak of his fame and affluence he came back to Dublin to play a leading part in the reorganisation and updating of Dublin art-teaching. George Moore was among the prestige figures involved in this, which centred on the old Dublin Metropolitan School of Art. Orpen had also some exceptionally gifted Irish pupils and followers, though they belong to a later chapter. His contemporary William Crampton Gore (1877-1946) was a quieter, more refined and more domestic painter, close stylistically to Orpen's brother-in-law William Nicholson. A genuine little master, he painted landscapes and numerous still lives and interiors – pictures with real subtlety of lighting and compositional flair.

Orpen had no use for the conception of an independent Irish art, any more than he sympathised with the ideals of political independence from Britain. At the same time, he was a thorough Dublin Protestant of the outgoing, sociable kind, entertaining Pavlova in

Jammet's now-vanished restaurant as a kind of national and personal duty; mixing with Moore, Gogarty and other writers, socialites and wits of the mileu; encouraging and advising younger artists; taking a crucial role in Lane's collecting and allied activities; as well as painting everybody within range. Small and ugly, he was nevertheless a great lover of women and painted himself beside a statue of Venus as his tutelary deity; he made many erotic drawings, some of which – such as the Paris brothel ones done in the company of Augustus John and other choice spirits – have only been shown recently in public. Orpen was as witty and sharp in his drawings as his Irish literary contemporaries were in print or in talk, and the theatrical bravura which flavours so much of his work has a tongue-in-cheek, burlesque, parodistic quality which is often lost on the solemn naivete of modern art scholars.

Meanwhile, Hone lived on into the Great War, revered by the few and ignored by the many, farming and painting to the last. To people such as Bodkin he was the patriarch of Irish art, even though he stayed outside the Revival and seems to have been only tangentially aware that it was happening at all. Osborne was dead since 1903, though his teaching remained a living influence, and Lavery stayed uninvolved in Irish affairs until his wife's infatuation with Collins. But a new generation was emerging, some of whom were to bridge the gap or transition from Anglo-Ireland to the new State and its post-revolutionary society.

Its key figure is yet another Yeats, "Jack B." as he was still affectionately known in Dublin long after his death. Since Yeats was born in 1871, he was actually older than Orpen, but grew into Ireland's leading Modernist while Orpen never made the transition into the postwar world, either emotionally or artistically. Yeats had done some desultory art study in London, though he said in later life that the formative influence on his whole psyche was the years spent with his maternal grandparents, the Pollexfens in Sligo – "Sligo made me a painter, and the skies over it". He produced a quantity of black-and-white illustration for a living, and painted in watercolour, scarcely working seriously in oils until he had turned

Before the Start by Jack B. Yeats (1915).

thirty. From the first he was recognised by his peers as something special and even unique, and "AE" (George Russell) foretold that he would be the "painter of Irish life" for whom his fellow countrymen had been awaiting for decades, like Jews for their Messiah.

In spite of the fact that he was admired and encouraged from his twenties, Yeats was rather a slow starter and a distinctly slow developer, though he never ceased to search out new tracks. His genial, sympathetic, though reticent personality always drew people to him, and he had what his poet-brother never had, the "common touch". It is, in fact, something of an enigma that while W.B. Yeats was self-consciously a pioneer in going to the Irish folk imagination as a primal source, in practice his brother was much more at home with, and in touch with "the people" than the poet ever was. W.B. Yeats at Coole Park always remained the frock-coated literary gentleman in search of local colour, going around notebook in hand, questioning the wondering but astute peasants who, presumably, knew where their bread was buttered and what sort of talk would go down best. In his writings he exalted the world of horsemen, fiddlers, fairs and fighters, yet intrinsically he remained the ultra-respectable Irish Protestant burgher, prudent and class-conscious, busy with committee work and literary politics, skilful in ingratiating himself with the great and the titled of this world (though in justice to him, he did refuse a knighthood). It is significant that the poet grew increasingly hostile to the democratic levelling of the post-war world and even became involved for a time with General O'Duffy's fringe and slightly comic-opera type of fascism, while Jack B. never wavered in his relatively undemonstrative nationalism and cared very little for social distinctions or drawing-room politics and intrigues. He had no difficulty in moving emotionally from Anglo-Ireland to the new nationalist one, unlike "AE", Gogarty, and others who went into exile.

Since the beginning of the present "revisionist" stage of Irish history and thinking, a phase which has lasted over a quarter of a century and now urgently needs some revision in turn, it has

become almost ritualistic to decry the chauvinism and narrow orthodoxies of the new Irish State and to point out how many eminent figures, mostly Protestant or of a Protestant background, chose to go abroad. But as I have mentioned already, Irish artists had been going abroad for centuries, for a variety of reasons, and cultural emigration after independence merely continued the trend. It is still the trend: most living Irish writers are in England or America. London was the great international centre of art activity and publishing, while Dublin was not and could never be one because of graphical, economic and demographic factors which no mere changing of the flag over Dublin Castle could hope to alter much.

Orpen's nostalgic slice of autobiography *Memories of Old Ireland* recalls a Dublin which probably was doomed even if the break with Britain had never taken place. Essentially it was the world of the late Victorian and Edwardian upper crust, which in Ireland happened to be largely Protestant. There was undoubtedly a Protestant exodus from Ireland in the decade after the Great War: civil servants whose loyalty had been to the British Crown; land-owners and gentry whose houses had been burned down in the Troubles and their cattle, land and horses stolen and killed; bailiffs, land-stewards and retainers fearful of potential violence from land-hungry countrymen; all sorts of professional and commercial people who could not accept that their traditional dominance and privileges had ended forever. In retrospect, the Irish War of Independence can be seen largely as a class war and an agrarian struggle, though our current obsession with economic and class factors can easily obscure or belittle its quite genuinely idealistic, patriotic aspect.

At any rate Jack Yeats, Ireland's greatest modern painter, stayed at home and does not seem to have nurtured any regrets about doing so. He always had a London following, and in America John Quinn was only one of his influential admirers. He also had links with France, which culminated in the French nation awarding him the Legion of Honour, so it can be seen that he was no isolationist or narrowly "national" genius. Yet if he had chosen to be another

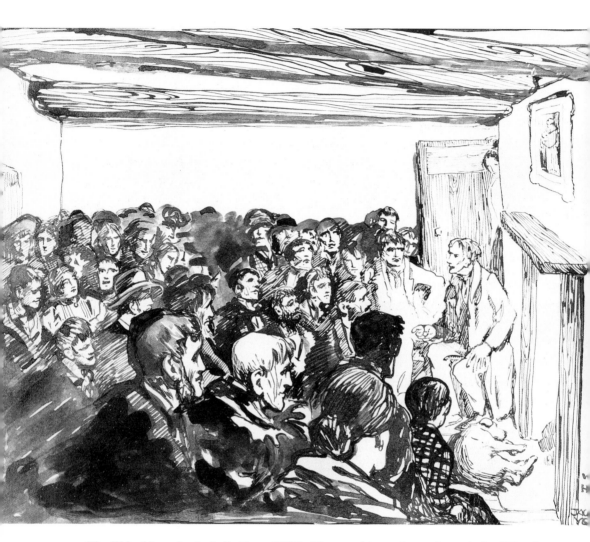

The Wake House by Jack B. Yeats (1908). The graphic starkness is typical of Yeats' early style.

artistic *emigré* or exile, it is fairly safe to predict that his reputation abroad would now be on a par with his friend Beckett's, if not even with Joyce's. Stay-at-home geniuses are not usually of much interest to British or American critics, and in Ireland itself the thrust of revisionist opinion has led to the curiously uncritical swallowing of many Anglo-American myths about Irish culture, including the apotheosis of the genius who got away.

In spite of the curtain of isolation, which is still widely believed to have closed down Ireland's artistic and intellectual horizons during the Second World War, Yeats more than managed to keep abreast of his British contemporaries. It is often claimed that he had no interest in the painting of his peers and "never looked at anybody"; even early in his career, George Moore recorded how bored Jack always appeared in the National Gallery. But many painters are bored or oppressed by galleries – Braque, for instance, in later life refused to enter them and used instead to send in his wife, Marcelline, to "tell me what's good in there". The totally self-made, self-educated painter is a myth or an abstraction, considering that artists in their formative stage learn mainly by studying the work of others. In fact, Yeats's early work in oils is close to the kind of Sickert-orientated genre style which then dominated Britain, and his folksy subjects show an awareness of Millet and early Van Gogh, though in a filtered, indirect way rather than at first hand. There is also a very definite legacy from French Romanticism, Daumier in particular – Orpen remarks, in the book already quoted, on the strong posthumous influence of Daumier on Irish art early in the century. There are traces of Géricault in some of his horsey subjects, and I have seen, in a private collection, a drawing which is an obvious reminiscence of a Delacroix painting of Arab horses being led down to water. Finally, there is some watered-down legacy from Impressionism, particularly from Degas (who, of course, also painted horses), shown in Yeats's "cropping" of his figures to enhance a sense of close-upness and immediacy. Some of the early works too are faintly Whistlerian, though this again was a kind of diffused essence of the age. Yeats seemed to have

sucked in material from everywhere – old circus and music-hall posters, folk tales and broadsheet ballads, magazine illustrations, photographs, literary subjects of all kinds including his childhood reading. No art has a more "democratic" basis in the real meaning of the term, and you never find in his work the art-school flavour which in Orpen, for instance, is often inescapable.

Yeats is to a great extent the painter of the Literary Renaissance, and almost inevitably he had literary ambitions himself; some of his odd, ultra-personal plays are still in print, and his novels such as *The Charmed Life* still have a cult following (I cannot read them myself). His sensibility, however, is not in essence literary even if at times it does seem to run in harness with his brother's, or with Synge, or with Seumas O'Sullivan, Somerville and Ross, James Stephens, or with other writers major and minor. With Synge, in particular, he had a close sympathy as well as a close friendship which led to their collaboration in the books *In Wicklow and West Kerry* and *The Aran Islands*, for which Synge wrote the text and Yeats did the illustrations. Another close friendship was with the English poet John Masefield, whose feeling for the common man – sailors, slum-dwellers, tramps, prizefighters, jockeys – ran parallel to his own. Some of Masefield's narrative poems, in particular, seem tailor-made for Yeatsian illustration – *The Everlasting Mercy*, or *Dauber* with its seafaring types, or the racecourse epic *Right Royal*.

For much of his career Yeats shared his place as the leading Irish painter of the new generation with a Belfastman, Paul Henry (1877-1958), the son of a Baptist minister, who had studied for a while in the Académie Julian in Paris and briefly under Whistler. Henry became one of the painter laureates of the Free State when his work was enormously popular and for years was even reproduced on calendars and railway posters. Yet most of his very best pictures had been painted before 1920 and his later popularity stemmed largely from the wrong reasons – because he created or established a sterotype of the West of Ireland landscape, compounded of looming mountains, sudden, almost apparitional small lakes, peat-bogs and thatched cottages, a kind of God's Own

Country untouched by mechanisation, capitalism, urbanisation or materialism. This was a vision of life which had a special appeal in the 1920s and the 1930s, when the cities and towns of Ireland were full of the newly emerged Catholic middle class, many of whom looked back on their country origins or forebears with deep nostalgia. It also suited the mood of de Valera's Ireland, which exalted the smallholder and the self-sufficiency and moral hygiene of rural life – a mood and outlook found not only in many poets, playwrights and novelists of the time, but even in the writings of certain economists and political theorists. Typically, when this phase petered out finally after the Second World War, Henry was made the scapegoat for an attitude which he had not originated and for an alleged escapism which is not inherent in his best or most typical pictures. He cannot be blamed for the sentimentalities and insipidity of his would-be followers and imitators, even if he did end up painting rather like them.

Henry was essentially a late Realist who felt the influence of Millet and the early van Gogh, though he also saw Post-Impressionism at first hand and absorbed the lessons of Cezanne and contemporary French thinking about *valeurs* and "essential form". Brought up an Ulster Protestant, he had nationalist leanings, but he did not set out to be a "national" artist or a practitioner of what the Germans call *Heimatkunst*. His early pictures were faintly Whistlerian, and like Yeats he did a substantial amount of commercial black-and-white work, as well as occasional portraits. The turning-point of his career came almost by chance, when he was living and working in London and went to Achill Island for a holiday. He ended up staying for seven years (1912-19) and a high percentage of the work by which he lives was painted in this period.

Henry was not an inventive painter and he was never a colourist of the Yeats type; certainly he entirely lacked Yeats's temperament and imagination. His chief strength lay in the bold simplifications he imposed on the Irish landscape, bringing out its "essential form" in Cezanne-like masses, or in broad Van Gogh-like rhythms. He frequently uses a hard horizon line above which he piles up the

Man on a Telegraph Pole by Paul Henry. Henry's west of Ireland landscapes made him famous, but he was also a fine draughtsman in black and white.

massive clouds and skies so typical of the West of Ireland, while a single cottage huddles in the foreground with its black turf stack, or a small lake gleams luminously blue. Almost always in his pictures there are mountains, blue and flat in the distance, or grey sea-inlets, such as the beautiful *Killary Harbour*, which has an atmospheric delicacy possibly derived from his early admiration of Whistler, but also shows the telling use of falling diagonals which Henry may have learnt from Seurat's seascapes. Many of his best and most typical landscapes are without any human presence. When he peoples them it is usually with labouring peasants or fisherfolk, or countrywomen with bowed shoulders and red shawls, types which he could see all round him in the West. A typical work in this vein is *The Turf Cutters* (Trinity College, Dublin) in which the figures have an almost Van Gogh-like strength and monumentality and are also welded integrally into their setting. Henry was a fine, stark draughtsman in black and white, and his drawings are as sought after nowadays as the best of his paintings.

Henry's love-affair with the Western seaboard, which he wrote about as well as painted, was really the making of him as a painter, the binding-agent of his rather undirected early energies. In late middle age he slowly declined and became little more than an old-style academician, though he was never a reactionary and played a busy part in promoting modern art of the Paris School in Dublin. He was also, by virtually unanimous verdict, a good, kindly and open-natured man, without personal jealousies or pettiness. His first wife (he had two) was Grace Henry (*née* Mitchell), a good though uneven artist in her own right, and the best of his followers or fellow travellers was James Humbert Craig (1878-1944), from County Down, who was a rather more varied painter than Henry but lacked either his formal compression or his solidity as a draughtsman.

All these artists stayed and worked in Ireland, but as before, there were either those who went and returned or those who stayed away. The best of these *émigrés* is probably W.F. Leech (1881-1968), who had studied under Osborne at the RHA schools ("the best

The Cigarette by William Leech.

teacher I ever had") and then, almost inevitably, at the Academie Julian in Paris. Almost inevitably, too, he painted in Concarneau, Brittany going there annually for some years. One of his best-loved works, *Quimperlé – the Goose Girl*, dates from this time and is in a mildly Bastien-Lepage vein, but with a sensitivity to light and a glow in the colours which the Frenchman never equalled. Her solitary figure, set against a Millet-like sylvan background, has an unconscious pathos and naturalness which the Frenchman's stiff, mannered poses utterly lack. *'Twas Brillig*, shown at the Cork Rosc exhibition of Irish art in 1977, is a true masterpiece, depicting a group of children playing against a luminous sky – a picture whose sheer visual poetry makes it hard to forget.

By this time Leech had moved to London, and he hardly set foot in Ireland again for the remainder of his long life. He had spent most of the First World War in France and then, apparently, decided that England was his real home and that he had no real role or interest in the newly emerging Ireland. Though he kept up his links with France, English influences gradually grew stronger until Leech became, in everything except name, a Franco-English artist, typical of the Frenchified and "advanced" type of RA. Yet in spite of this increasing conservatism – and he had never been an innovative painter at any time – his inborn touch never deserted him. It comes out particularly in his small oil sketches, many of them little master-pieces which have an emotional freshness and an ability to pin down the essentials of the subjects: a boat in a stream, the corner of his studio, a nook in his garden. Above all, they show the grasp of light effects which he had mastered in his years in France.

Leech painted many portraits, but with a few exceptions they are not his best creations and his figure paintings tend to be rather academic and empty. He is at his purest as a painter of luminous interiors, of gardens in sunlight, or of some angled view from his studio window – in short, as an *intimiste*, an Anglo-Irish equivalent to Bonnard and Vuillard in a minor key. Ironically, England, his adopted country, has remained largely unaware of him – though he seems to me a much better artist than, say, Vanessa Bell or Mark

Gertler – and up to the end his admirers were mostly Irish. Though he never came to Ireland for the last half-century of his life, he continued to exhibit regularly in old age at the now-vanished Dawson Gallery in Dublin.

The same gallery was largely responsible for reviving interest in the work of Mary Swanzy (1882-1978), probably Ireland's best woman painter and yet another product of Anglo-Ireland nurtured by France. This formidable woman also worked under Osborne and I remember hearing her talk of him a few years before she died, as though he were a living presence, though he was then seventy years dead. An upper-class Dubliner, with the self-assurance of her class and background, she was as much at home studying art in Paris as in travelling as far afield as the South Seas, where she painted pictures which are sometimes compared with Gauguin's, but are in fact much closer to Augustus John and the "picturesque" side of the academic tradition. Swanzy took a long time to form a genuinely original style, and though she saw Cubism at first hand in Paris, and even met Gertrude Stein and her set, her many Cubist paintings are not essentially different from those of several dozen other talented, but derivative artists of the time. In fact, her alternation of Modernist and academic styles can be highly disconcerting; while working in a Cubo-Futurist style, she was capable of reverting abruptly to the purest Royal Academy traditionalism.

However, even her quasi-Cubist works are never merely formalist, and there is a romanticism and an aura of fantasy about them comparable to the Russian Alexandra Exter, who of all the *emigré* artists of the Paris School is nearest to her mentally. At heart, Swanzy's dilemma was that she was essentially a romantic individualist, not a formalist like her near-contemporary Mainie Jellett, nor an enlightened, accomplished traditionalist like Leech. Apart from clarifying and aerating her colour sense, Paris Modernism had relatively little to give her – though, of course, its intellectual excitement and unique sense of unlimited possibilities were intoxicating to the legions of young painters from abroad. Swanzy had to work out

Sir Hugh Lane by Sarah Cecilia Harrison (*c.*1914). A capable portraitist, the artist was a friend and admirer of Lane.

her own salvation, which she took a long time to do, though even her most derivative work has personality and an innate painterliness. In retrospect, her slow and isolated development has a good deal in common with Jack Yeats's long, obstinate pilgrimage to originality and uninhibited self-expression.

The mature, inimitable Swanzy style is not easily put into words; it has a dreamy, erotic mood contrasted with a harsh, angular, ultra-personal fantasy – sweet and sour combined, dream and night-mare. However, its most striking element is the colour, rather close to Chagall's in its unfocused, haloed, visionary quality which often overlaps the forms and has its own self-contained logic apart from them. Yet these are very much "subject" pictures and as in Jack Yeats, the subject is not translatable into words. This is visual poetry, not painterly prose, existing in its own hermetic yet accessible world. Daumier and Goya seem to have left their mark, and perhaps Rouault; but the end-product remains as self-contained as the finest Surrealist pictures. Swanzy's clowns, acrobats and beggars, *demi-vierges* with flowers, her riders and boats and other painting "props", all seem to be acting out some enigmatic, ultra-private ballet of the subconscious, to which the spectator lacks the key but is still drawn insidiously. Few major painters have been more uneven or incon-sistent, but she is one of the true originals of Irish art.

Swanzy had been living in England for many years in relative obscurity before the Municipal Gallery of Modern Art showed her work again to Irish viewers with a retrospective exhibition in 1968. However, she has had no real influence on modern Irish art – certainly none to compare with those two other Cubist-inspired women artists, Mainie Jellett and Evie Hone, who are less original and interesting than she, when considered purely as painters. This entire period, in fact, proliferates with gifted women painters, including Sarah Cecilia Harrison (1864-1941), an able portraitist who left one memorable painting of Hugh Lane to whom she was close; May Guinness (1863-1955), who was decorated by the French government for her services in the First World War and whose traditional paintings are usually more convincing than her artificial,

Enigma by Beatrice Glenavy (*c.* 1930). A close friend and associate of Orpen, Lady Glenavy (born Beatrice Elvery) was a leading figure in the early days of the Free State.

self-consciously Cubist ones; Estella Solomons (1882-1968), who was active in the nationalist cause and friendly with many of the figures of the Literary Revival (she married the poet Seumas O'Sullivan) is best known for her portraits, but was also an excellent landscapist; Mary Duncan (1885-1960), English by birth but Irish by sympathy, who ended up living and painting in Cornwall; Beatrice Glenavy (1883-1968), the wife of Lord Glenavy, the financial oracle of the early Free State, whose work is variable but includes a number of highly original, quasi-Surrealist pictures. She was one of the circle around Orpen, and studied in Paris and also at the Slade.

These artists make up, collectively and individually, a very remarkable generation of women, all of whom were authentic personalities in their own right as well as influential and active in many fields. They were, in fact, Ireland's emancipated generation, independent-minded and sometimes vocally feminist – notable organisers and crusaders for various causes, sometimes to the extent of becoming sheer busybodies and meddlers in almost everything around them. Sarah Purser (1848-1943), who belonged to an older generation, began as yet another Irish student at the Académie Julian and later moved in most of the leading Paris circles of her time. She was a professional portraitist of considerable talent and as a hostess and organiser she was able and tireless, helping Hugh Lane in his campaigning and also playing a central role in the crafts revival early in the century. Finally, there are the watercolourists, Mildred Anne Butler (1858-1941) and Rose Barton (1865-1929). Both were traditionalists who in essence belonged to the late Victorian world, but both were capable of stepping outside the conventions of the schools and each left a solid body of work, some of it on a surprisingly large scale for watercolour painting. Mildred Anne Butler worked briefly in Cornwall under Norman Garstin, as did Clare Marsh (1874-1923). Ireland, it can be seen from all this, certainly had no shortage of able women painters, and the tradition lives on to the present day.

Le Petit Dejeuner by Sarah Purser (*c.*1882). Sarah Purser, who lived into her nineties, was as famous as a hostess, organiser and wit, as she was for her painting.

6

Into the Modern Movement

IN ONE SENSE, Modern Art did not occur in Ireland – not, at least, in the sense that it happened in most other European countries, where culturally it was as complete an upheaval as the Great War was politically. Leaving aside any over-ambitious comparisons with France or Germany, the ferments and revolutions of pre-1914 European Modernism did not come to Ireland until the 1920s, and even then only in an attenuated, second-hand form. It is arguable, of course, that they came almost equally late to Britain, where critics still found Augustus John mouth-gapingly original and daring at a time when the more advanced continental and American buyers were already collecting Picasso and Matisse. Yet even Wyndham Lewis's Vorticist movement, though it was in many respects meretricious and second-hand, showed at least an awareness of what was in the air and of the need to catch up with the great, vital international currents. By comparison, Ireland at the time was still caught up in the Lane controversy, and was finding it difficult to come to terms even with the Impressionists. There were, of course, Modernist enthusiasts and even collectors in Dublin, but they were mostly isolated figures and certainly not typical of their milieu.

The credit for introducing Cubism and French Modernism as a whole into Ireland is generally given to two remarkable women, Mainie Jellett (1897-1944) and Evie Hone (1894-1955), who have already been mentioned in the previous chapter. By background,

inevitably, they were Anglo-Irish gentlewomen who took the boat to Paris in 1920 after studying in Dublin and in London under Sickert. The fashionable teachers of Modernism in Paris, at a time when Cubism was already becoming a salon style, were André Lhote and Albert Gleizes, both second-rate artists but excellent theorists and educators, as well as able technicians in their own right.

Up to this period Hone and Jellett had worked in fairly traditional modes, touched slightly by the second-or-third-hand Modernism which had filtered into London from France. They quickly left Lhote for Gleizes, working under him annually for years and thoroughly absorbing his codified, eclectic brand of Cubism. In turn, they introduced this style into Ireland, where they became intensely active and influential as teachers, theorists and propagandists for Modernism. In the tradition of so many Irish women artists, they were also excellent organisers and had a strong social sense, which culminated in the leading role they played in the establishment of the annual Irish Exhibition of Living Art in Dublin in 1943. Jellett, in fact, never showed at the IELA, and was terminally ill when its first exhibition took place.

Unquestionably, this remarkable duo did a great deal to popularise Paris Modernism in their homeland, while their achievements as energisers and inspirers can hardly be overrated. It should be remembered, too, that they had to face very powerful, heavyweight opposition from many quarters, including the RHA, which was then almost entirely dominated by reactionary followers and pupils of Orpen. In the early years of the Free State, waves of fresh, youthful and forward-looking energy came up against stagnant lakes of insularity and entrenched, often ignorant, prejudice, while the new *bourgeoisie* formed in the wake of revolution was already stabilising itself into a new conservatism. The outward and inward-looking factions often clashed; and in the 1930s in particular it sometimes seemed as if the latter was dominant and that Ireland might lapse into provincial isolationism, or into a rather cranky, defensive form of puritanical nationalism.

It is fashionable nowadays to blame this mainly on the Catholic

Church, though in fact it had its progressive and reactionary wings, like almost all other institutions, and its record in patronising the arts is better than is usually realised. A new, dully oppressive lace-curtain respectability made itself felt in many fields. There was the wearisome tendency to copy British institutions and trends at second-hand and at least a decade too late; and some of the former revolutionists and reformers were among the first to settle – either comfortably or wearily – into the new conformity. It is a familiar story to anybody who has studied the history of revolutions, but it was still bitterly disillusioning to Irish writers and intellectuals such as Sean O'Faolain, who had fought for a radically new and different Ireland. Certain external factors, such as the (now almost forgotten) Economic War with Britain in the 1930s, helped to strengthen this isolationist type of nationalism and encouraged Ireland to withdraw into herself and to concentrate on cultivating her own potato-patch. In view of the gathering storm-clouds in Europe and elsewhere, this attitude is very understandable. Irish political isolationism, however, has been exaggerated: the role of de Valera in the League of Nations is a case in point.

Behind this, inevitably, there was a muddy substratum of that national vice, the inferiority complex, which at heart felt that all cleverness was better left to foreigners and exotic countries, while Ireland stuck to the tried, the familiar and the dull. A homespun art in a stock pictorial language, with little imagination or invention or even real emotional intensity, was the only kind of art such a mentality could abide. This explains largely why Paul Henry, for instance, grew more popular as his originality and force became blunted and conventionalised, and why routine academy portraiture and sterotyped West of Ireland peasant subjects acquired such a quasi-official, institutionalised acceptance. Charles Lamb and Sean Keating (an Orpen pupil and later President of the RHA) are not actually bad painters, and Keating's drawings are sometimes as distinguished as Henry's. Yet because they suited the mood and needs of the time by turning a ready-made idiom into the service of Irish subjects – Western fishermen, crossroads dancers, farm

labourers and the like – they were acclaimed as a new national school. In fact, Lamb stylistically was no more than a minor English academic painter and Keating painted in a rather run-down Orpenesque style, with occasional flashes of Augustus John. Their Western peasants were essentially country cousins of John's equally theatrical, stylised gypsies, though without the sheer *élan* and tongue-in-cheek verve which spices John's big figure pieces and saves them from banality.

So, in this provincial context, Hone and Jellett were two angels of light, bringing the torch of progress and enlightenment to a backward and rigidly enclosed milieu. Their example and propagandising had a historical importance beyond their actual achievement as painters. Evie Hone went on to become a considerable stained-glass artist, while Mainie Jellett was a pioneer of Abstract art in Ireland and also of a new kind of religious art which still has its admirers. Yet viewed retrospectively, Jellett's relatively traditional early work is probably still her best, while Hone's fresh, direct works in gouache are almost always more convincing than her formal Cubist or Cubo-Futurist canvases.

Harry Clarke was a genius in stained glass but his work belongs in another context; so do the major sculptors of the time, who in any case were more the heirs to Rodin and the nineteenth century than they were genuine Modernists. Henry, as has been mentioned, was by this stage repeating himself with less and less inner conviction; Swanzy had little influence and was rarely in Ireland, in any case. Irish independence, which started with such high hopes for a national art, now seemed perilously divided between the "official" academics, such as Keating, and the "semi-official" Paris Modernists, such as Jellett and Hone, who were bravely and conscientiously attempting to transplant an exotic which never quite took root and flourished. The only painter genuinely able to bridge the two epochs and styles was Jack Yeats, who was acceptable on one hand to the more enlightened of the academics (he showed regularly at the RHA exhibitions) and on the other was respected by avant-gardists as a man who followed

The Pirate by Jack B. Yeats (1903). One of Yeats's popular illustrations, many of which were used on ballad broadsheets.

his own, idiosyncratic line of development and was a daring and highly original colourist.

Privately, Yeats is something of an enigma, in spite of the gentle magnetism of his personality, his reputation as a host, and his apparent geniality and accessibility to all sorts and conditions of people. He was not an intellectual, though he drew intellectuals to him; neither was he a socialite, extrovert and *bon viveur* as Orpen was; yet people of all sorts liked him and sought him out. Unlike Hone, Jellett, Osborne and so many others, he did not have pupils, and few people ever watched him at work. Private but sociable, a dreamer and fantasist, yet no fool in money and professional matters; a man whose talk always drew listeners but who was not a wit or a conversationalist; a bohemian among the *bourgeoisie*, and a *bourgeois* among bohemians, he seems as elusive to pin down in his life as he is in his art. What is certain is that he was more popular than his brother. In later life, W.B. Yeats's hieratic airs and increasing social snobbery repelled or inhibited many younger people who were drawn to him as a writer, while Jack Yeats seems to have been remembered with affection by virtually all who encountered him personally.

The early watercolours have charm and an intimate lyricism; the mass of illustrative work he turned out, both in colour and in black-and-white, always had a kind of broad, popular balladeering vitality, and certain relatively early paintings such as *Bachelor's Walk* (1913) have their firm place in the national mythology. Yet much of the earlier work is also opaque and almost monotonous in colour, and there is still rather too strong a flavour of the illustrator, as if he remained tied too much to traditional genre subjects or to the imaginative world of his literary contemporaries.

From the early 1920s his style began to change into a kind of highly charged, moody *intimisme*, romantic yet based on everyday observation, exemplified by such works as *In the Tram* and *The Liffey Swim*. Over the next few years his colour began to grow markedly more luminous and expressive – almost Expressionist, in fact – and his brushwork grew correspondingly freer, so that

the paint-strokes created and moulded his forms rather than merely followed them. This development grew steadily stronger over the next two decades, until the typical, mature Yeats canvas was enriched with impastoes, sudden highlights, slashes of pure colour, and with figures, shapes and faces which emerged or half-emerged suggestively from an iridescent mist of paint.

There is a mystical side to Yeats, though he left mythology in the stricter sense to his brother, and in his art if not always in his life, Jack was far the earthier of the two. Some commentators have claimed to find him too whimsical and escapist – but that is to miss the point. He has, in fact, a Dionysiac side to his psyche, and his singers and musicians, in particular, seem possessed by some demonic force or ecstasy. Yeats frequently draws his imagery from the music-hall and the circus, but there is no sense of any aesthetic toying with life at a safe, bookish, sedentary remove, in the old nineties manner. Though he is capable of great poetic refinement, his race-course scenes reek of sweat, horsedung and leather, and his Dublin street scenes bring back the old sour smells and racuous voices of the slums. Like Joyce, his imagination is impregnated by the mud and trivia of reality, and he finds his own emotional world where an aesthetic sensibility would retreat in disgust.

His favourite and most potent image, however, is probably the horse, which becomes a symbol of the life energy itself, creative and destructive by turn; a symbol of reckless abandon and perhaps, too, of spiritual freedom and imaginative release. Horses and the thud of hooves haunt his whole output, from the very early watercolour of a Devon horse fair, to some of his last enigmatic masterpieces such as *There is no Night* (Hugh Lane Gallery, Dublin) which is supposed to refer to the death of his wife and may have some message of reunion and resurrection. In *Grief* (National Gallery of Ireland) a mounted figure on a white horse appears to be ordering a group of men, women and children into captivity or exile, or perhaps even to execution, against a fiery blaze of red that seems pregnant with blood and carnage. This may be some condensed recollection of the bloodier moments in Irish history, but Yeats

might also have had the Second World War in mind, and the massacre of the Jews. In spite of his apparent isolation, he was as alive to the hopes, fears and agonies of his time as the great continental Expressionists; and the time cannot be far off when Ireland's finest painter is numbered as their equal.

Histories of twentieth-century art have been oddly reluctant to grant Yeats his place in the hierarchy of great painters. He always had powerful admirers, including Kenneth Clark and Kokoschka (who called him the last painter in the great tradition and wrote him a letter of homage during Yeats's last years), Thomas McGreevy, Samuel Beckett and many more. Certain Modernist critics preoccupied with formal values could not admit that he was anything more than a figure on the European fringe. Seen objectively, Yeats is only one of the various major but isolated modern figures who bypassed Cubism and the more formalist aspects of Modernism, tracing their real descent from Impressionism or Symbolism, or both – Munch, Bonnard, Rouault and Chagall among them.

It is significant that the stock of all these men has risen sharply in the last decade, as the Neoclassical values of the first half of the century gradually recede, and it is only a matter of time before Yeats too is seen at his proper worth. It may indeed be happening to him already, judging by the rapidly spreading waves of interest in his work which began roughly with the National Gallery of Ireland's major exhibition of his work in 1976, a revival which ended nearly twenty years of eclipse after his death. The 1991 exhibition at the Whitechapel Gallery in London has revived his reputation in England. We seem now to be on the threshold of a new kind of Romantic age, and Yeats is one of the great twentieth-century Romantic painters. Incidentally, his very late work plainly comes within close range of Abstract Expressionism, in spite of its relatively small scale and its tendency to hold firmly to some anchoring subject matter, no matter now enigmatic and veiled. He died the year after Jackson Pollock, of whom he had probably never heard.

Whatever his international standing may be, historically one thing seems past disputing: with Yeats, the transition was made from the

predominantly Anglo-Irish or Franco-Anglo-Irish art of his immediate predecessors, to an art which had indigenous roots among the Irish national psychology. It is easy to be misunderstood in this context, particularly when Ireland happens to be engulfed in a wave of enthusiasm for internationalism in the most vague and uncritical sense – an enthusiasm which sounds dismayingly like inverted provincialism in some aspects. Yeats was a thoroughly European painter, but he was also a deeply and consciously Irish one.

Today internationalism, sadly, has been too often debased to the level of a kind of airport culture in which people dress the same, buy the same pop records, stay at identical high-rise hotels and eat the same food. Art, too, is much the same everywhere. To a great extent, this unprecedented cultural uniformity is the result of a quasi-democratic levelling – the long-awaited Age of the Common Man, reaching out automatically to his mass-produced supermarket culture as he does for his hamburgers and frozen vegetables. From another aspect, which is probably the more insidious, it is the result of a complete dominance of commercial values, the mass-production conformity of corporate world capitalism.

To ignore the steady growth of internationalism in the better sense would be very foolish indeed, even reactionary, and few people of sense would deny that European unity is a desirable and even necessary aim – provided, of course, that it is not just another skilfully cloaked move towards rule by the pirate flag of international high finance, in concert with the cold, polished, black-suited army of Eurocrats. Cultural and economic isolation is obviously a thing of the past, not only because it is politically discredited, but because it would be impossible to achieve or maintain given today's level of communications, travel, and mobility of capital. Just as artists and writers of the Romantic Movement reacted against the banality and philistinism of bourgeois life thrown up by the new commerical order in the wake of the French Revolution, so perhaps a new generation will react against the levelling uniformity and spiritual vulgarity of the social order which has taken shape in the last quarter of a century. It also seems fairly safe to predict

that one of their weapons to combat this malaise will be their own national cultures and traditions, which survive not through mere nostalgia or chauvinism, but through their own inherent vitality, and which always yield a new harvest when a new *Zeitgeist* demands it. In short, the new Europe must be an interplay of many cultures and traditions, not a featureless international supermarket selling mass-produced, standardised artefacts.

John Hughes, Sculptor by Walter Osborne (1903). A rare case of a major Irish sculptor being drawn by an equally gifted painter.

7

Irish Sculpture

THE WAVE of Celtic Revivalism which swept over nineteenth-century Ireland did not produce much of lasting vitality in the field of sculpture, if indeed it produced much of importance at all. The depressing vistas of neo-Celtic High Crosses which can be seen in almost any Irish graveyard today, urban or rural, are aesthetically on a par with the wolfhounds, shamrocks and harp motifs of the early Celtic revival, and are as dated in essence as eighteenth-century chinoiserie. In the field of crafts and decorative arts, this trend yielded some interesting and valid results, but sculpture is something which demands established traditions of craftsmanship and patronage to stay alive and vigorous. Ireland had few sculptural traditions since the late Middle Ages, and the better sculptors who worked there in the eighteenth century were usually foreigners.

The Celtic revival was as valid in its essence and intentions as the Gothic or the Neoclassical revivals, but unlike them, it had a very limited legacy on which to build. Gothic Revival architects had the great cathedrals and other surviving buildings before their eyes, to supply them with models; Neoclassical sculptors and painters could draw on the eighteenth century, on the Renaissance, and on the incomparable artistic riches of Greece and Rome. By contrast, the Celtic High Crosses dotted through the land did little except provide models – badly understood, for the most part – for funerary masons and the more commercial type of monumental carver. In architecture, it was possible for an interesting if

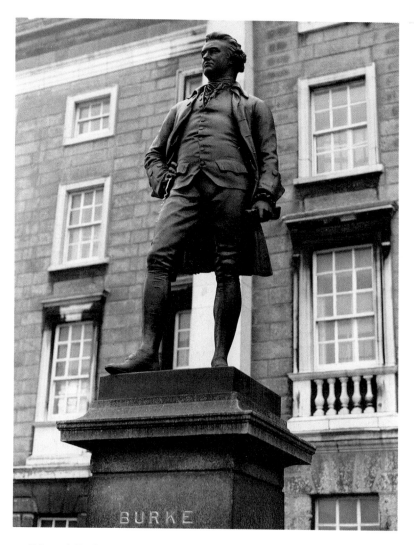

Edmund Burke by John Henry Foley (1868). This lifesize bronze statue stands outside the front gate of Trinity College, Dublin, alongside that of Oliver Goldsmith.

Oliver Goldsmith by John Henry Foley (1863). Foley was Ireland's greatest sculptor of the nineteenth century, though most of his active career was spent in London.

short-lived school of Irish neo-Romanesque to emerge. But while Ireland did produce a number of excellent sculptors in the nineteenth century and the early twentieth, there is nothing like a continuous, evolving national style, or indeed any consistent style at all. The good ones of the time were much like those in other lands: international eclectics following in the uniform style of almost all nineteenth-century sculpture in Europe and America. It is, indeed, one of the curiosities of art history that, almost everywhere, the sculpture and architecture of this period remained so dependent on Classical, Renaissance and Gothic prototypes, while painting, like literature, was so often shaped by local and national currents.

The finest, by general if not unanimous consent, is the Dubliner John Henry Foley (1818-74), who followed his elder brother into the profession, studied at the Royal Dublin Society art schools as a boy, and then moved to London while still a teenager. He first came to public notice in the Royal Academy exhibitions and in 1840 he was one of the artists chosen to decorate the new Houses of Parliament, producing statues of Selden and Hampden for St Stephen's Hall in Westminster. Foley strengthened his standing by the equestrian statues of Lord Harding and Sir James Outram, two heroes of the Raj – a proof that the Irish-born artist was already becoming the leading sculptor of British imperial might. After his *Egeria* and *Caractacus*, both commissioned for the Corporation of London and carved in marble, came the most prestigious commission of his career, for the Albert Memorial. He carved the statue of Prince Albert and the *Asia* group, establishing himself as the leading sculptor in the British Isles – and, in the process, overstrained his nerves and health badly.

In the 1860s, he created two of his best-loved works, the *Burke* and *Goldsmith* in bronze which stand outside Trinity College, Dublin. In the same decade he was given the commission for the O'Connell Monument in Dublin, in the street and beside the bridge which now are named (they were not then) after the great patriot-orator. There were the usual, almost inevitable intrigues and accusations that he was "a London artist", not a legitimate Irishman,

and as it turned out, Foley did not live to finish the task. A slow, ultra-conscientious worker, he found it difficult to cope with the many commissions that came his way and left several others unfinished at his death, including the magnificent equestrian statue of General Gough which used to stand in the Phoenix Park. This was blown up a generation ago by those who regarded it as a symbol of British supremacy though Gough, a bluff, honourable Indian army general, was Irish by birth and did his fighting against the Sikhs, and not against his fellow-countrymen. It seems that Foley's health never fully recovered from the strain of the Albert Memorial commission, just as Maclise's nervous system was permanently sapped by his mural commissions in the House of Lords.

Foley, as has been pointed out many times, was not an innovator, or even a man of exceptional creative imagination – the *Asia* group, for instance, does not show him at his very best, and the O'Connell Monument is more impressive in terms of individual figures than in its rather static, stumpy overall ensemble. Yet while it is relatively easy to point to his limitations, not even the most bigoted anti-Victorian could deny his obvious strengths – the sheer life and nervous vitality of his free-standing figures, the feeling for individual character (he was a good portraitist, which enhances the force of the Burke and Goldsmith statues, for example), his sureness in picking exactly the right, most economical and most expressive poses, the authority and sense of scale which made him so suited for public statuary. In particular, he knew well how to catch that special mixture of virility and intellectual distinction which the Victorians so much admired, and which made the whole age the extraordinary thing it was. Compared with his great French contemporaries Rude, Preault and Barye, he may seem almost sedate, but he has a sober, manly strength which counterpoints their expressive rhetoric.

In spite of his quasi-official role as the statue maker of Empire, Foley kept up his links with Dublin and showed regularly with the RHA. Though he was buried in St Paul's, he bequeathed the casts of his work to Dublin, which – all too typically – did not do much with them. However, the Burke, Goldsmith and O'Connell

A Girl Reading by Patrick McDowell (1838). McDowell was best known for his public statuary, but this white marble statue betrays a more intimate and personal aspect of his work.

statues, which stand only a few hundred yards apart, make him an inescapable presence in the centre of Dublin and familiar to thousands who do not know his name. No art works are woven more densely and intimately into the fabric of national and urban life.

John Hogan (1800-58) is Ireland's leading Neoclassicist, a role in which he has few real rivals either in sculpture or painting. He was born in County Waterford but served most of his early apprenticeship in Cork – including a series of anatomy lectures – and copied from the casts of classical statuary in the gallery of the Cork Society of Arts, a collection on which local patriots have always plumed themselves a great deal. Patrons raised money to send him to Italy, so in 1824 Hogan arrived in Rome where he studied and worked energetically, earning the respect of the leading English sculptor John Gibson, and even that of Thorvaldsen who greatly admired his *Drunken Faun*. He married an Italian wife, did some religious works for the Irish clergy and was elected to the Virtuosi del Pantheon, founded in 1500 – "to which no British subject had hitherto belonged", according to Strickland. Hogan might well have settled in Italy for the rest of his life, but the 1848 Revolution sent him back to Ireland. It was the great *faux pas* of his career, from which it never recovered; Ireland, desiccated and demoralised by the Famine, had little to offer its sculptors, particularly an austere idealist such as Hogan. In between the few important commissions which came his way, he had to carry out various pieces of hackwork and was repelled by the provincialism of the milieu around him, particularly after cosmopolitan Rome.

One of the major humiliations of his life came when he was passed over for the statue of Thomas Moore in College Street, Dublin, in favour of Christopher Moore (1790-1863), a competent but characterless portaitist. Hogan's last years make sad reading; he was soured by ill health and neglect and perhaps, too, by his own difficult, touchy character. Intellectually and socially, Hogan is the central sculptor of the new Catholic Ireland which arose after Emancipation (just as J.J. McCarthy became its typical architect) even

General Jean Lafayette by Andrew O'Connor. The hero of the American and French revolutions is shown on horseback, dashing and energetic.

Irish Tinkers by Louis le Brocquy (1948). Works such as this seemed revolutionary in the conservative Irish art world of the forties and fifties.

Liffey at Night by Tom Carr (*c.* 1942). The Soft handling and objective observation are typical of the work of this conservative artist.

Portrait of Kate O'Brien by James Sleator (*c.*1946).

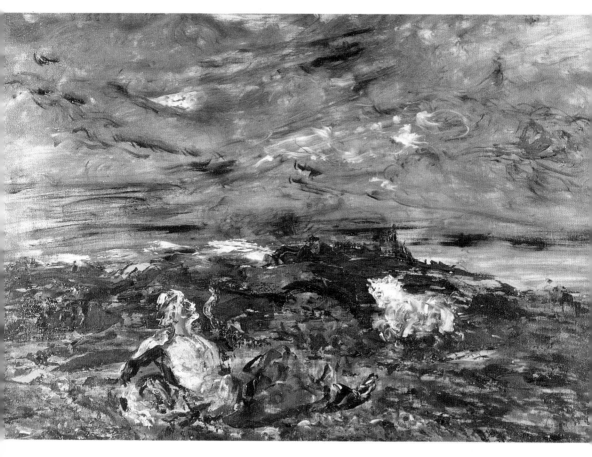

There is No Night by Jack B. Yeats (1951). This picture is reputedly associated with the death of the artist's wife and with his belief in a reunion beyond the grave.

Cats in the Kitchen by Nano Reid (*c.* 1952). Fantasy, humour and informality are all qualities of Reid's work.

West End Village, Tory by James Dixon (*c.*1958). Dixon, a Tory Island fisherman-farmer, began painting in old age and is now regarded as Ireland's leading "primitive" artist.

Late Harvest, Donegal by Derek Hill (1959). Though English by birth and training, Hill is closely identified with Ireland and the Irish landscape.

Last Still Life by Colin Middleton (1983). Middleton was one of a generation of gifted Northern Irish artists who helped to make the Irish Exhibition of Living Art a vital force in the years after the Second World War.

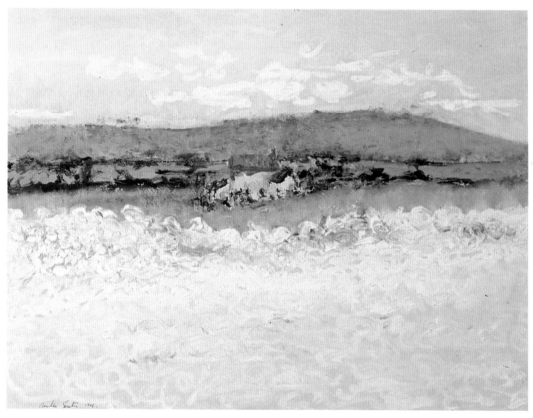

Waiting to Go On the Canal by Camille Souter (1968). The subtle understatement of Souter's style has won her a special niche in contemporary Irish art.

Portrait of Seamus Heaney by Edward Maguire (1974), the leading Irish portraitist of his generation.

Ireland 111 by Patrick Graham (1982). Sometimes grouped with the New Expressionists of the 1980s, Graham is nonetheless an independent figure in contemporary Irish art.

Bogland by Sean McSweeney (1982). McSweeney's style represents a highly personal synthesis of Abstract Expressionism and the landscape.

The Foundation Stones (Mental Home) by Brian Maguire (1990). Maguire's work often reflects urban decay and social unrest.

Slow Turn by Charles Tyrrell (1987). Nature-based abstraction offset by a strong geometric element forms the basis of Tyrrell's highly individual style.

Midsummer Window with Moths by Tony O'Malley (1992).

Bend in the Road by Nancy Wynne-Jones (1992). Trained at the St Ives school of Abstract art, Nancy Wynne-Jones has recently found a new theme in the Irish landscape.

Blue Grid by Sean Scully (1992). Scully is an abstract artist of international repute who is chiefly associated with the New York school.

down to his social and personal edginess and insecurity. It is significant that he worked a good deal for the Church and also made statues of the heroes of the Catholic and nationalist revival – O'Connell, Father Mathew the temperance preacher, and Bishop Doyle of Kildare and Leighlin (the famous "J.K.L."). Stylistically, he is closer to the virility of Thorwaldsen than to the salon elegance of Canova, but there is a streak of academic coldness in his work which keeps you at a distance. Nevertheless, his calibre becomes very rapidly apparent if he is compared with the pseudo-classicism of Irish sculptors such as Moore and Thomas Kirk.

Hogan and Foley were the leading sculptors of the mid-century; perhaps the only other figure worthy of note is the Belfast-born Patrick MacDowell (1799-1870) who, like Foley, went early to London and carried out a number of public commissions there, including the statue of Turner in St Paul's, as well as portrait busts. He was, in fact, highly successful in his day and his career was climaxed with the *Europe* figure for the Albert Memorial. McDowell's public statuary is mostly routine stuff, well-made but uninspired, but he was also capable of real delicacy and sensitivity, especially in his smaller sculptures.

It is hard to see exactly how Augustus Saint-Gaudens (1846-1927) can be fitted into Irish art, since he was born in Dublin of a French father and an Irish mother and moved to America when he was six months old. He studied in Paris and spent years there and in Rome, becoming, in fact, one of the most cosmopolitan Americans of his day in the kind of mileu in which Henry James moved and which he describes in his novel *Roderick Hudson*. His reputation was very big in his day, and he was close to Theodore Roosevelt and created statues of various Civil War heroes, including Lincoln and General Sherman. Saint-Gaudens's main link with Ireland, after his first six months of life, was that he was commissioned to do the Parnell Monument in central Dublin, a dignified piece of work, but no masterpiece – especially if it is compared with the calm, pulsing life of Foley's statuary nearby.

Later in the century, however, three considerable sculptors

The Fairy Fountain by Rosamund Praeger (1900-01). Praeger's career as a sculptor was almost entirely confined to her native Ulster.

appeared: John Hughes, Oliver Sheppard and Andrew O'Connor. Hughes (1865-1941) was born in Dublin, studied in London, Paris and Italy as well as at home, and lived much of his life in France and Italy, before dying in Nice. He was a much-respected and influential teacher in Dublin at the turn of the century, before he gave up teaching to live entirely by sculpture. Hughes was not an innovator, but he was a solid and sensitive traditionalist who later in life came slightly under the influence of the giant of *Belle Époque* sculpture, Rodin. One of his chief strengths was as a maker of portrait heads, but *The Man of Sorrow* and *Madonna and Child*, which he did for Loughrea Cathedral, rank among the relatively few examples of good Irish religious art of the past century. Hughes's real love was the Italian Renaissance, but he never sinks into pastiche or into hackwork. Fine finish and an innate refinement are in almost everything he created.

Sheppard (1864-1941) like Hughes studied in Dublin, London and Paris; he too became an influential teacher after his return to Dublin. However, while Hughes identified himself more with British and French art trends – he even made a large public statue of Queen Victoria – Sheppard became a pillar of the national movement, creating perhaps the most memorable of all images of the national struggle, the 1798 Memorial in the Bullring in Wexford. This full-length, lifesize figure represents a single marching pikeman, stalwart and frank, his pike at the ready and his head thrown back – an obvious tribute not only to the local '98 rebels but to the spirit of the French Revolution, which had inspired Ireland at the time. Sheppard is at his best in this kind of vigorous, straightforward, "popular" piece, charged with romantic and national feeling; his *Cuchulain* in the General Post Office in Dublin (now commemorating the 1916 Rising, though actually it predates it by some years) shows the muddling influence of Symbolism and the more pretentious, literary side of Rodin's art. Both these works are in bronze, but Sheppard shows another side of himself in his smaller marble pieces, which have a softer, more intimate and more feminine charm.

Andrew O'Connor (1874-1941) was born in Worcester,

Street Singer by Jerome Connor. Pieces such as this show the Irish-born, American-trained sculptor at his most sensitive.

Massachusetts, but he was of Irish blood and identified himself closely with Ireland in his later years, eventually dying in Dublin. Like Sheppard, he was a robust, realistic, straightforward artist, best in a popular and monumental style, and full of the same fresh, open-hearted patriotic fervour. Many of his major works are in America, such as the statue of Lincoln for the latter's home town of Springfield, Illinois, and like Saint-Gaudens he also commemorated military heroes of the American Civil War. His bronze *Lafayette on Horseback* was done for Baltimore, but a rather smaller version exists in the Hugh Lane Gallery in Dublin and exemplifies the nervous vitality and energy typical of O'Connor's best work. The statue of Daniel O'Connell in the National Bank, Dame Street, Dublin, is less monumental than Foley's but has a quality of dramatic immediacy and presence which O'Connor may have taken partly from Rodin's *Balzac*. O'Connor's grandiose plan for a monument in Boston to Commodore John Barry, the Irish-born sailor who was one of the founders of the American navy, was never carried out, but it might well have been his masterpiece. The small bronze of the main figure, in the Hugh Lane Gallery in Dublin, shows the great seaman balancing like an athlete to the roll of the ship under him – a superb conception and a nervously vital piece of modelling. Unfortunately, O'Connor too felt the pull of Rodin's late, quasi-mystical phase and his *Christ the King* caused the Irish clergy of the time to reject it. Long after his death, it was taken out of obscurity and mounted in Dun Laoghaire, just outside Dublin, but those who had hopefully praised it as his masterpiece were not justified. Strained and over-complex, it shows O'Connor out of his depth in quasi-Symbolist subjects. He was really at his best with folk heroes, generals, patriots, and it is a tragedy that the Irish Free State did not employ him more in that capacity, when he was eager for the role as well as ideally suited to it. In the Crawford Gallery in Cork there is a bronze head called *La Faunesse* for which his future wife modelled; it represents the more intimate side of his art and can stand beside the very best Rodin heads.

In the North, an altogether gentler and more domestic kind of

sculpture was produced by Rosamund Praeger (1867-1954), whose father had come from The Hague as a boy and set up as a linen merchant – the nineteenth century was the heyday of the Northern linen trade. She studied at the Slade School in London under Legros, the *emigré* friend of Rodin, but her active life was spent between Belfast and in her home-town, Holywood in County Down. Rosamond Praeger was sometimes sentimental, but she had a rare feeling for children, shown in *The Philosopher* (marble, Ulster Museum) and in *Johnny-the-Jig*, which shows a little boy playing an accordion and now stands out of doors in a children's playground in Holywood. Like so many other Northern artists, Rosamond Praeger could catch this kind of folksy note very well, but she was a sophisticated woman who was also an excellent illustrator of children's books – some of which she wrote herself. She was close to the stained-glass artist Wilhelmina Geddes and her brother was that remarkable Irishman, the naturalist Robert Lloyd Praeger, author of the classic *The Way That I Went*, whom she commemorated with a bronze bust now in the National Gallery of Ireland. Belfast, in the early years of the century, was a city with a good deal of intellectual life.

Jerome Connor who, like Andrew O'Connor, grew up in Massachusetts is generally reckoned an Irish artist, though at least half of his creative career was spent in the US. His family emigrated from County Kerry while he was a child, and in America he came to sculpture through apprenticeship to a commercial stonecutting firm. Connor was almost fifty when he came back to Ireland and became deeply involved in the art of the Free State, making relief portraits of the leading Government members and designs for the new coinage. He is best remembered for the Lusitania Peace Memorial in Cobh, County Cork, on which he worked for well over a decade, but his bronze statue of Robert Emmet is one of the classics of Irish nationalism – the doomed young patriot is depicted addressing the court which condemned him, his head thrown back and full of the eloquence of idealistic youth. This work was originally cast for the Smithsonian Institute in Washington, but

An Strachaire Fir by Joseph Higgins (*c.* 1920).

there is now one in St Stephen's Green in Dublin. Connor (1876-1943) is yet another Irish sculptor who shows Rodinesque fingerprints, but he is an independent, virile personality in his own right. His *Erin* was recently cast in bronze and erected in St Stephen's Green, where in my opinion it suffers by being placed too low; it may not be vastly impressive as an allegory, but it does make a thoroughly convincing female figure. His small bronze heads, particular those of women, are sometimes little masterworks.

There is a strange pathos about the short career of Joseph Higgins (1885-1925), a Cork sculptor who was almost unknown during his lifetime and whose work has only been seen in any quantity quite recently. Some of them were not even cast in his lifetime and were only done so later on the initiative of his son-in-law, the Cork portrait-sculptor Seamus Murphy. Besides his bronzes, Higgins carved finely in wood and marble. Higgins had a very distinctive cast of mind, sensitive and introspective, and he was particularly successful with his heads of children. A typical work, *Boy with a Boat*, is now in the Fitzgerald Park in Cork, a belated gesture of recognition to a rare talent.

8

The Crafts Revival

THE PHRASE "Celtic Twilight" became first a term for a specific literary fashion, then later a journalist's cliché, and more recently, a ready-made term of denigration by ambitious writers and critics who saw themselves as modernisers clearing away the debris of a dead style and outlook and bringing Ireland into the modern world. Since the term has lost much of its meaning, it may be useful at this stage to ask what it meant originally.

Any English literature student will answer that it began with certain nineties writers such as "Fiona McLeod", who in private life was an Englishman called Sharp. W.B. Yeats in his early period belonged to the same trend, which centred in London, not Dublin, and had affiliations with spiritualism and other anti-realist, anti-rationalist cults of the time. The vagueness and ethereality of nineties art bear no relation to anything in Irish literature before that date, nor to its art either; neither do they have an obvious ancestry in England, apart from the work of certain minor Romantics. The Twilight, then, was essentially an exotic plant in the insularity of late Victorian England. Its literary side was really an offshoot of continental Symbolism and was largely imported by Francophiles such as Arthur Symons, Yeat's close associate and his oracle on all things French. In its visual aspect, it had a remote ancestry in Blake and Palmer; but nearer at hand, it was also a late growth of Pre-Raphaelitism, descending from Rossetti through Burne-Jones and William Morris.

Just how much this milieu meant to the young W.B. Yeats is plain from reading his *Autobiographies*. Morris was an oracle and a substitute father-figure to him, and the effect of Burne-Jones's art on his poetry can be seen clearly, for instance, in *The Wanderings of Ossian*, in which several of the episodes read like the *Briar Rose* series turned into verse. This trend in his work reaches a climax in *The Shadowy Waters*, in which late Pre-Raphaelitism is crossed with the twilight world of Maeterlinck to produce a curiously anachronistic but haunting masterpiece. It is strange that recent literary criticism has taken so little notice of this key work, even allowing for the fact that Yeats's early phase still is ultimately under a cloud; yet it is, in fact, one of the last visionary glimmers of European Symbolism. The two lovers, Forgael and Dectora, drifting towards nothingness in their deserted ship, are unmistakably a belated echo of Wagner's *Tristan and Isolde*, and represent a kind of poetic-dramatic *Liebestod* with all its concomitant longings for passion, infinity, release and love-in-death.

This apparent tangent is pursued here because it was precisely this aspect of Yeats's early work which gave the Celtic Twilight term such currency and has coloured attitudes to the entire revival in almost every field. Yet the painting of Jack Yeats, the plays of Synge and Masefield's poetry were largely a reaction against the nineties in favour of the more vulgar and vernacular. George Moore too was a realist, a disciple of Zola's; while O'Casey's slum plays are hardly ethereal or typical of the nineties! It is true that Celtic mythology played a major part in the movement, but this represents only one side of it and one which had very little effect in the visual arts, in any sense. There is no Irish equivalent to Böcklin or Redon or Puvis de Chavannes, only the mythological paintings of "AE", which for the most part are dim and unrealised. Why there was not, cannot be answered here, but then geniuses do not emerge on demand. There was, however, one major Symbolist figure in the visual arts – the stained-glass artist Harry Clarke (1889-1931), who was also an illustrator and black-and-white artist of rare gifts.

Clarke was born in Dublin, the son of an English-born

church-decorator who, amongst other activities, supplied clerical and other clients with stained glass in competition with the much-abused "Munich glass" then imported in large quantities. Stained glass was undergoing a rebirth in Ireland, and in 1903 *An Tur Gloine* (the Glass Tower) was set up in Dublin, largely by the energetic Sarah Purser and Edward Martyn, the playwright, cousin of George Moore and near-neighbour of Lady Gregory in Galway. (As almost always happened at this time, the writers and artists interlinked and often worked in harness together.) They recruited London craftsmen trained in the William Morris tradition, and did their best to train a new generation which could combat the commercial vulgarity of most church art at the time.

Harry Clarke studied briefly in London at what is now the Royal College of Art, but most of his considerable technique was gained either in his father's workshop, or at night classes in Dublin. An early landmark in his career was the Irish International Exhibition staged in Herbert Park, Dublin, in 1907, where he first saw Beardsley illustrations and works by Rossetti and some of the continental Symbolists. He won gold medals at prestigious competitions in London, showed his glass abroad in Dresden and in 1914 went on a scholarship to France, where the windows in Chartres Cathedral overwhelmed him. The following year he got the commission for the masterpiece of his early period, and perhaps the central masterpiece of his whole output, the windows for the Honan Chapel in Cork. This building, incidentally, was designed by James F. Mullen, one of the more interesting Irish architects of the period, and was consciously modelled on the striking Romanesque architecture created for the Irish church in the eleventh and twelfth centuries (a figure of St Finbar by Oliver Sheppard stands over the west door).

Here Clarke, then only in his middle twenties, created one of the central masterpieces of twentieth-century Irish art. "Beardsley-esque" is an adjective applied to his work many times over, and although he tended to play down the Beardsley influence himself, it is plain enough in his illustrations, even in some of the stained

glass. It is irrelevant to the Honan windows, which are hieratic, Byzantine, and so powerful and original in colour that it is hard if not impossible to think of any European equivalent to them since the Middle Ages. They seem almost to belong to the Greek Orthodox religious spirit rather than to the Roman Catholic ritual – there was, of course, a kind of filtered Russian influence at work at this time, stemming mainly from Diaghilev and his designers (Clarke was an admirer of the *Ballet Russe*) and the painters who had grouped themselves around the magazine *Mir Isskustva*. In any case, a strain of Byzantinism was inherent in Irish Christian art from its earliest beginnings; it can be seen plainly in the great illuminated manuscripts such as the *Book of Kells*, and this Celtic Byzantinism played a large part in forming Clarke's very individual imagination and style.

For the rest of his short life Clarke worked with driven energy, directing and inspiring a studio which turned out windows for many Irish churches (Catholic and Church of Ireland alike) and for commissions from Britain and even further afield. Because of their geographical scattering, it is not easy to see his work in bulk, but it is plain that while it varied in inspiration – some of his clients and patrons were rather narrow and dogmatic, or simply hard to please – he never sank to commercialism or hackwork. He also made small glass panels, either for private patrons or for specific exhibitions, which contain some of his subtlest touches – a good example is the *Queens* series of 1917. *The Eve of St Agnes* (Hugh Lane Gallery, Dublin) is a good example of his later, less monumental style, more subtle and even precious; in place of the solemn, mysterious, suffused glow of the Honan windows, there is more reliance on small jewelled highlights which pierce the eye like light flashing off a precious stone. There is also in these later works a morbid, mannered, slightly "decadent" flavour which may have been emphasised by the tuberculosis which was beginning to take root, and from which Clarke eventually died. Shortly after this came the great *contretemps* of his career, the affair of the so-called Geneva Window which had been commissioned by the Irish Free State

as a gift to the International Labour offices of the League of Nations in Geneva.

Clarke at this time was in high favour; patronised by the Catholic Church, a gold medal winner at the Tailteann Festival (*Aonach Tailteann*) organised by the Government in 1924, and praised in public by W.T. Cosgrave, then head of the Free State government. Since Irish writing had a world readership at the time, he conceived the idea of using the window to illustrate the work of leading Irish writers, including Yeats, "AE", Synge, James Stephens and O'Flaherty. The writers themselves were enthusiastic; but when the window went on preliminary exhibition in his Dublin studio, officialdom began either to take offence or take fright – possibly both. In particular, the panel illustrating Liam O'Flaherty's story *Mr. Gilhooley* (which, admittedly, looks more like Wilde's *Salome* than it resembles O'Flaherty's raw realism) seems to have upset the lay censors, who were already beginning to emerge as a major source of nuisance and artistic inhibition in the new Ireland. The window was rejected officially; Clarke, already a sick man, retired to Davos, to the sanatorium described in Thomas Mann's *The Magic Mountain*. Ironically, he was to die in the country for which the window had been intended, and to complete the humiliation, his widow was forced to refund to the State the fee for her husband's work. The Geneva Window vanished from view for decades until, in the 1960s, it went on loan to the Dublin Municipal Gallery of Modern Art (now Hugh Lane); but official ineptitude recently allowed it to be sold to an American museum and it is now lost to Ireland.

Clarke's voluminous output as an illustrator and black-and-white artist is more familiar to many people than his stained glass; for many years bibliophiles and others have collected editions of the books he illustrated. Poe, Coleridge, Goethe and Perrault are among the authors whose work he "recreated" – they are more than simply illustrated – in his own nervous, mannered visual language, which in this field owes not only an obvious debt to Beardsley but also to the graphic work of Bakst, Edmund Dulac, Erté, and other fashionable international figures of the day. In his

Moore Street by Michael Healy. Healy was primarily a stained-glass artist, but his many notebooks of small on-the-spot sketches are much admired today.

stained-glass techniques he was a restless experimenter and an almost agonising perfectionist, original in his use of acids and other secrets of his trade.

Meanwhile, Sarah Purser had discovered the Northern artist Wilhelmina Geddes (1885-1955) and drew her into *An Tur Gloine* and the Dublin arts-and-crafts milieu. Born in Leitrim but brought up in Belfast, Geddes had studied under Orpen in Dublin and did needlework pictures and watercolours, like so many Irish Protestant gentlewomen of the time – it was the heyday of the Arts and Crafts Society of Ireland, whose tone was predominantly Anglo-Irish and upper-crust. Her stained glass does not have the nervous, brittle, brilliance of Clarke's, but she has an austere, almost Old Testament quality which is peculiar to her, as well as a strong sense of abstract design. After she had moved to London in 1925 and set up a studio in Fulham, she carried out many prestige commissions, including two war-memorial windows, for St Bartholomew's Church in Ottawa and another in Ypres Cathedral, in honour of King Albert of the Belgians. *The Fate of the Children of Lir* (Ulster Museum, Belfast) is a very impressive piece of new-Celtic mythology, the kind of imagery which "AK" failed to realise in painting, and there is work by her also in the Hugh Lane Gallery in Dublin and a collection of her designs in the National Gallery of Ireland. It was at her kiln at Fulham, in London, that Evie Hone worked to turn her own stained-glass designs into reality. Geddes is a considerable artist at her best, though a good deal of her work has vanished or been destroyed, some of it in the German bombing of Belfast during the Second World War.

The third important artist of *An Tur Gloine* was Michael Healy (1873-1941), a retiring Dubliner. Healy's work exemplifies the simple four-square, popular side of the crafts movement. He also appealed to the traditionalists of the arts revival and the country clergy of the epoch, for many of whom Clarke was a little too clever, too cosmopolitan and aesthetic. His *Simeon* window in Loughrea Cathedral, County Galway, is probably his best-known work, and shows that Healy was essentially a late Victorian. But he too

could be a glowing colourist, and the *Last Judgement* (also at
Loughrea Cathedral) is a big, intricate work of almost Expressionist
power. Stained glass apart, Healy was an enormously gifted
draughtsman – one of Ireland's finest – who filled innumerable
notebooks and sketching pads with swift, on-the-spot impressions
of the sights, streets and characters of Dublin in his day. Many of
them are in wash, which he handled dexterously, and it is a puzzle
that nobody has thought of reproducing them in book form, either
on their own or as a visual accompaniment to the stories of
Stephens or the plays of O'Casey. In themselves, they bring an en-
tire milieu visually to life, and they have an essential Dublinesque
humour in their quick, sure observation of a Dublin which is as
extinct as Sickert's old gaslit London.

With Evie Hone, whose career and personality have already been
described, the golden age of Irish stained glass comes to a close;
she is the last major artist of what was a very striking welling-up
of talent. Though she owed a good deal – particularly in
technique – to Geddes, she moves into a new era, that of French-
based Modernism. Clarke belonged in essence to Symbolism and
Art Nouveau, though with a personal, contemporary twist; Healy
and Geddes developed the late Victorian and Arts and Craft tradi-
tion in their own very individual ways and brought them into the
twentieth century. But Evie Hone fully belongs to *Art Moderne* and
her main influences were from the School of Paris. She is more
decorative than her predecessors, with the characteristically French
love for broad, contrasting areas of reds and greens and blues; she
also used the theories of Gleizes's highly conventionalised Cubism
for her own ends, sometimes ordering her colours in a kind of
"wheel" and simplifying her figures into flattened, stylised shapes.
Evie Hone was a Catholic convert, which gave her extra impetus
in her church commissions, and like Rouault – whom she greatly
admired – this also drove her to learn from French Gothic art.
The result, however, was not neo-Gothic pastiche, though some-
times she fell into the chic, dated, neo-primitivism all too typical
of her era. There is a heraldic glow and sincerity in her best

windows which makes most of her painting, by contrast, look decorative and contrived.

Hone's most acclaimed works are probably the Eton College Chapel windows, which made her famous in England in the last years of her life (she was a semi-invalid for most of it) and *My Four Green Fields*, which used to greet visitors to the Coras Iompair Eireann offices in O'Connell Street, Dublin, but has recently moved to Government Buildings in Upper Merrion Street, Dublin. There are important works in University Hall in Hatch Street, Dublin; and in the Catholic church in Kingscourt, County Cavan, she created a series of glowing windows – her best works, she is said to have claimed. St Michael's Church in Highgate, London, has a lucent, stylised *Last Supper* which sums up her later style (it was put up in 1955). In a very remarkable and varied generation of Irishwomen, she is one of the most admirable, particularly in view of her long and continuous battle against ill-health, and her spirituality was deep and hard-earned.

One of the curios of art, a long and eccentric effort carried out inside convent walls, is the decoration of the little chapel of the Dominican convent in Dun Laoghaire, near Dublin. This was executed by a nun, Sister Concepta (born Lily Lynch, the daughter of an illuminator), who worked there for nearly twenty years, covering the roof and walls with stencilled and painted Celtic ornament. She took her shapes mainly from illuminated manuscripts such as the *Book of Kells*, and from Celtic and Norman metalwork and carving, combining them in an overall effect which seems, when you step into the little room, to carry you back to some imaginary Middle Ages. This artistic oddity, produced in isolation from modern trends, is more convincing than most of the neo-Celtic illumination and embroidery associated with the Dun Emer Guild, in which the moving spirits were the Yeats sisters, Lily and Elizabeth (Lolly).

Lily Yeats, yet another member of that astonishing family, had worked with May Morris in England and had organising abilities as well as the creative flair seemingly endemic in her family. The Dun Emer Guild produced some fine banners for Loughrea

Cathedral – that showpiece for the arts and crafts of the time – but the Yeats sisters' finest achievement was the Cuala Press, which lasted for many years and to which their brothers, W.B. ("Willie") and Jack, both contributed. The Cuala Press, a kind of Irish equivalent to Count Harry Kessler's famed Cranach Press in Germany, not only produced books which are works of art and still collector's items, it also gave some of the most gifted young poets of the time a new outlet. Today, its products are either collectors' items or cherished heirlooms.

The career of Eileen Gray (1888-1976) lies outside this context, since she spent almost all her creative life abroad and hardly identified with Ireland in any way, and so belongs much more to continental or international design than to any national trend or movement. She has only been rediscovered in the last decade and a half, though she was an influential figure as far back as the 1920s who seems to have met or known virtually all the international figures of her time. Eileen Gray's work in design and architecture, elegant and austere, is far closer to the Bauhaus than to any Irish equivalent – or, for that matter, to any English one either. Her standing as a pioneer, however, seems to rest on a slender output, whether in architecture or in designs, and in Ireland her influence in her lifetime was negligible. She was purely a prophet abroad, belatedly honoured – an all-too-frequent *leitmotiv* in Irish intellectual life.

9

The Modern Epoch

ACCORDING TO the current revisionist view, Ireland from
the 1930s onwards sank back into a state of almost unqualified
isolationism and provincialism and has only recently emerged from
this limbo both intellectually and politically. The recent mood of
self-congratulation over Ireland's Europeanisation needs as its
counterpart the iconic vision of a benighted Ireland turned fatal-
istically inwards, cut off from the great pulse of modern civilisation,
obsessed with its own past and narcissistically contemplating its
own face in some holy well or bog-pool.

The subject is far too wide to be dealt with adequately here, but
even superficial study of the epoch between 1930 and 1950 will
show how one-sided, or even false, this too-fashionable viewpoint
is. Certainly, literary censorship was no myth, but this was also
a time of keen intellectual debate, with violent literary polemics
and controversies – an age which produced some excellent poetry
and many fine short stories and a national humourist and satirist
in Myles na Gopaleen/Flann O'Brien/Brian O'Nolan. It was the age
of *The Bell* and other courageous, *engagé*, highly literate journals,
as well as of genuine, committed Europeanisers and avantgardists
who confronted the chauvinists and conservatives. Contrary to
present-day opinion the Modernists won the victory, even if at the
time they did not know it. And in no field is this more true than
in Irish art, which threw up a vital new generation in the darkest
years of the Second World War, when it was cut off from Paris

Jack Butler Yeats by James Sleator (1943).

and had only limited contacts with London.

It is ironic that in the field of art Ireland's so-called reactionaries should have consisted mainly of the pupils and followers of Orpen, who only a generation before had rejuvenated the country's art teaching and had also been one of Lane's chief advisers. Orpen's pragmatism and sheer professionalism, and his devotion to discipline, hard work and a well-schooled technique, produced in turn a generation of artists who were talented, devoted to their craft and profession, and rather lacking in imagination or the higher awareness that painting was not merely a skilled craft, but also an expressive art like poetry or music. For the most part, they understood only the kind of art they had so thoroughly learned. They regarded Modernism as charlatanism or raving, or simply as technical inefficiency, and saw themselves as guardians of eternal values, when they were really only the dying fall of late nineteenth-century realism. In the early decades of Irish independence these men were almost all-powerful, with the result that the Royal Hibernian Academy became a reactionary body – not that it had ever been very much else – which simultaneously thwarted and force-fed the rise of Modernism. For years the walls of its annual exhibitions were studded with quasi-official portraits of leading civil servants, the new business class, eminent doctors, surgeons, bishops and occasionally politicians.

James Sleator (1889-1950) was so close to Orpen that he was actually chosen to complete some of his master's unfinished canvases. Apart from his ultra-competence as a portraitist, Sleator was also a good landscape painter and is, in fact, a much more gifted all-round artist than is realised today. Leo Whelan (1892-1956) also turned out portraits for a living, many mediocre and some of them good, but his finest work is in his interiors and genre subjects. Patrick Tuohy (1884-1930) is rather a different animal; he was not only an Orpen follower but a follower of Pearse and other leading nationalists, and he even fought in the 1916 Rising in Dublin, escaping to Spain. In Paris he got to know Joyce, who seems to have found his odd personality and depressive moods trying after a while,

Kitchen Window by Leo Whelan (*c.*1926). Whelan was one of the more sensitive artists of the "Free State" period.

and ended by leaving Dublin for New York, where he killed himself. Tuohy – whose malformed arm, caused him psychological problems – did not have a large output, but there is a sensitivity, a poetic, slightly melancholy mood, and a rich, highly individual colour sense in his paintings which puts him into a niche of his own. He is a genuine *petit-maître*, whose work is eagerly hunted out by collectors today, and certainly he was a changeling among the stodgy professionals of his epoch.

The most powerful and influential personality of all these was probably Sean Keating (1899-1977), who like Sleator rose to become President of the RHA and in the years after the Second World War was one of the focal points of Irish conservatism and even reaction in the arts, rather like his counterpart Sir Alfred Munnings across the Irish Sea. The irony is that back in the Free State era, Keating was regarded as a Green Hope of Irish painting, one of the corner-stones or lynch-pins of the newly emerging national school, and when he was chosen to paint the progress of the Ardnacrusha power scheme on the Shannon it seemed to augur a new, more enlightened era of State patronage. In fact, as has been said already, Keating was essentially another Orpen-schooled academician, by no means a contemptible one either – some of his drawings and smaller works can be excellent, for example. But the big, overstated, rhetorical canvases of freedom fighters, West-of-Ireland fishermen, hurlers and the like, which once flattered the national self-image and embodied many of the political aspirations of his day, are mostly as dead now as their nearest equivalent: British official war art.

The theatrical element so obvious in his work is not merely a legacy from Orpen – whose stageyness was very often tongue-in-cheek and intended to be taken as such. It was still a golden age of the Irish theatre, when plays, playwrights, actors and theatrical politics – particularly those at the Abbey Theatre – were subjects of national interest and were discussed by all social classes. Many of Lamb's and Keating's paintings are, in fact, like scenes out of some Abbey "peasant" play, down to the rather stilted

groupings and poses typical of stage productions of the time, and the costumes which look as though they came fresh from the wardrobe mistress and never saw cowdung or turfsmoke. In both cases, convention and heavy-handed artifice are masked as folk realism; stock characters and types pose as real people and a mild, costumed regionalism is substituted for genuine national character and racial vitality.

Free State art of this kind comes ready-made and it often resembles Soviet propaganda art. At its very best it is dignified and solid, though in a stock idom; at its worst, it is kitsch; and in-between these two extremes it is innocuous or mediocre. Above all, for a style which claimed to be expressing the heart of a newborn nation, it was all too plainly a provincial echo of the Royal Academy in London. There were, certainly, some gifted and honest painters in its ranks, most notably Maurice MacGonigal (1900-79), who sometimes Gaelicised his name as Muiris Mac Conghail. He became president of the RHA relatively late in life, and he was also an influential teacher for much of his career – a respected one too, open-minded even towards trends with which he could not possibly have sympathised. In general, MacGonigal represented the *juste milieu* of Irish art rather than its right wing, and his reputation has maintained itself when most of his academic contemporaries have been devalued. Some of his best and freshest pictures – mainly landscape – were painted when he had retired from teaching and from active art politics.

The Irish Exhibition of Living Art (IELA) was founded in 1943 at a time when Ireland was cut off from continental Europe by war, and even contacts with England were restricted. Various cliques of foreign artists existed in Dublin, some of them refugees from the Continent and England (including, a number of young men keen to escape wartime conscription). Hone and Jellett were two of the key figures in founding the IELA, though Jellett was already ill when the first exhibition was held and died shortly after it. For many years the president was Norah McGuinness from Derry (1903-80), who had studied under Tuohy in Dublin but essentially

was a Franco-Irish artist, and yet another Lhote student. A stylish and talented painter, without being a major one, she was also a formidable personality and organiser in the Hone-Jellett and Sarah Purser tradition, with an acute social sense and firm opinions about virtually everything. In short, another masterful woman in the Irish Protestant mould, and a useful person to lead the official opposition to Keating and the RHA.

From its inception until the late 1950s the IELA was the vital force in Irish painting, Jack Yeats and a few more of the older figures excepted. In retrospect, however, its most original painters were not Norah McGuinness or the various other French-orientated artists, whose work inclined towards decorative chic and even prettiness; it was certain independent artists who owed more to Yeats and who from the start showed a distinctively Irish sensibility combined with an innately modern sense of style and form.

Though the war years were so often blamed for Ireland's alleged intellectual isolation, they also helped to drive the writers and artists back in on themselves, their own resources, their native landscape and their subject matter. There is a strain of nature lyricism and poetic contemplation, for instance, in the work of Patrick Collins (1910-94) which is very different from the milder, more pastoral note of such an ultra-typical English landscapist as Ivon Hitchens. This painter, one of the finest of the last half-century in Ireland, seems to arrive at a distillation of landscape rather than a pictorial description of it – something which makes him closer to Oriental landscape-painting than, say, to the English watercolour tradition. Like Yeats, Collins grew up in Sligo and reacted imaginatively to the local landscape, but his colouring is misty and often dominated by grey-blue tones, through which a kind of gnomic imagery seems to rise slowly to the surface. Nano Reid (1905-81) studied at various times in Dublin, London and Paris and developed from relatively conventional beginnings into a powerful, densely textured Expressionist. Her late work is close to the American Action painters, though her colour sense is entirely her own – a web of opaque, almost muddy tones shot through with luminous greens and

yellows. Her imagery is simple, primitive and sometimes heavily abstracted, permeated by Celtic motifs which play an organic and not a literary part, and by a powerful feeling of nature. She also painted portraits and many marvellously lyrical watercolours which best express the essence of her intense, singing style.

Among the many gifted Northern painters who showed in the IELA, Daniel O'Neill (1920-74) might have developed into a kind of Irish Chagall; a 1940s neo-romantic with a subtle, softly glowing colour sense and a very individual mentality, he imbued everything he painted with a delicate, dreamy mood. He did not quite sustain the level of his early work, and his later output suffered from over-production and an obtrusive strain of chocolate-box sentimentality. Yet his finest work is within measuring distance of Yeats. Colin Middleton (1910-83) had a tougher and more resilient character, and over his long career he produced a large body of work which varied a great deal in style, but not in quality. Middleton is somewhat of a puzzle – one of the most naturally gifted Irish artists of his generation, he painted as a Surrealist, an Expressionist (with an obvious Yeatsian influence), a geometric abstractionist in the Ben Nicholson manner, a solid, straightforward landscapist, and even, occasionally, in the Euston Road style. The steady quest for a personal language apparently did not interest him and he preferred to work as an impulsive eclectic, picking up any style which interested him and filling it with his own very Northern personality. George Campbell (1917-79) was born at Arklow, County Wicklow, but generally regarded as a Northerner because he grew up in Belfast with his mother, the "primitive" artist Gretta Bowen. He worked in the quasi-Cubist style which became so popular after the Second World War – *vide* the world of the new generation of French artists at the time – with nervous, flecked brushwork and a quick, allusive style in which figures and shapes are suggested rather than realised. Campbell worked often in Spain, particularly in his later years, but like others of his generation, he did most of his best work in the 1940s and 1950s. Apart from his Spanish subjects, he also painted some evocative landscapes of the West of Ireland, whose cool,

greyish tonality contrasts with the hot tones of his Andalusian pictures.

Apart from the Living Art, one of the most powerful forces in introducing modernism to the Irish public was the Waddington Gallery in Dublin, which exhibited Yeats, Campbell, Middleton, O'Neill, Patrick Hennessy and Paul Henry. Victor Waddington – who later moved to London and, without any prior influence there, quickly became a power in the land – was a Dublin Jew who had graduated from humble picture-framing and selling pictures from door-to-door into the most far-seeing and magnetic art dealer Ireland had ever known. In his very different way, he was as important as Hone and Jellett and McGuinness (or such propagandists for modern art as James White, later director of the National Gallery of Ireland) because he found what Irish Modernism needed above all – buyers. He had a seventh sense in picking his artists, which he later showed in London by exhibiting most of the leading painters of the St Ives School, then Britain's avant-garde, but still relatively little known.

Another of Waddington's discoveries, and yet another of the Northern camp so prominent at the time, was Gerard Dillon (1916-71), who lived for periods in London but created some of his best work in the West of Ireland, where he was friendly with Campbell and Nano Reid. Dillon's strongest period, again, was in the war years and in the decade after, when he painted in a sophisticated, folksy, pseudo-naive manner with a crisp personal calligraphy, great humour and charm, and lyrical colour. At his best, he is a kind of Irish equivalent to the American Ben Shahn. Dillon was a man of all-round talents: something of a musician, a folksong collector and a noted raconteur. Some of his pictures of Belfast street scenes are classics of their kind, which should be made widely known to counteract the present image of that city as a smouldering volcano of bigotry and violence. So should the work of another Belfast artist, the much-loved William Conor (1884 – 1968), who belonged to an older generation. Conor has left an extensive visual record of his native city: its street life, pubs, facial types, its women

and children. He was also an excellent horse-painter – an important skill in Ireland – and much of his best work is in his black-and-white drawings and his coloured crayon drawings, just as Dillon did some of his most typical work in pastel.

The cult figure for a whole school of Irish Modernist taste has been Louis le Brocquy (born Dublin 1916), whose orientation has been highly "international", with little of the regional colour and accent of Dillon or Campbell. Le Brocquy began as an accomplished traditionalist, in fact as an academic artist, but he was an early exhibitor in the IELA as well as exhibiting at the RA and RHA exhibitions – something which became common when the RHA began to realise that it needed some of the new generation. His paintings of tinkers and tinker camps, mostly done in the late 1940s, caused a stir at the time, though their mildly Picassoist idiom belongs as much to the period as the work of the "two Roberts", McBryde and Colquhoun, does in Britain. In the 1950s he produced his "white" paintings, abstract works with a single amorphous white image, and more recently he has produced a series of isolated, almost spectral heads set against a greyish or monochrome background. These heads are based on those of Beckett, Joyce, Lorca and various other literary figures, and there seems to be some influence from Francis Bacon. Often described as a Franco-Irish painter, le Brocquy is really closer to English art of the 1950s though there is also a cerebral, unquiet, penumbral quality about his work as a whole which puts you in mind of Samuel Beckett. Some of his finest work has been done in the medium of tapestry, and his black-and-white illustrations to Thomas Kinsella's English version of the old Gaelic epic, *The Tain* (Dolmen Press, 1969), remain classics of their kind. Le Brocquy was a prizewinner at the Venice Biennale in 1956 and has been awarded France's Legion of Honour.

Equally cosmopolitan was the career of William Scott (1913-90), who was born at Greenock in Scotland of an Irish father and a Scottish mother, but has always been counted as an Irish artist. Scott, like le Brocquy, was essentially an international eclectic, responsive to successive art currents, yet never swept away by

Still Life by William Scott (1949). Typical of Scott's austere but painterly style, before his evolution into abstract art.

them. Early in his career, he was close to the Euston Road School; in Cornwall he discovered the works of the primitive Alfred Wallis, and he lived in France just before the outbreak of war. Scott's prewar work has genuine distinction, showing his clear, sharp, linear qualities combined with a subtle "tonal" sense, but he really found himself in the postwar years with a series of austere and slightly skeletal still lives, on which Picasso had left an obvious mark. Later, he moved into abstract forms and became close to artists such as Lanyon, Wynter, Frost and Heron of the St Ives school in Cornwall. He subsequently made contacts in the New York school and met Jackson Pollock. Scott was not an innovator, though always well up with the *avant-garde*; he was more a dedicated, self-critical craftsman-painter who combined superb handling with a spare, ascetic, almost minimal quality which reflects the puritan side of the Northern Irish heritage. Scott was given a retrospective exhibition at the Tate in 1972 and was well known on the Continent and in America, exhibiting in most of the large prestige international exhibitions.

Tony O'Malley (born 1913) has also been close to the St Ives School and was included in the "St Ives 1938-60" exhibition at the Tate in 1985. He grew up in Callan, County Kilkenny, where the stone carvings on the old Norman abbeys and churches in the area left their stamp on his imagination. For years he worked as a bank official in various parts of Ireland, while trying to paint privately, then painted in St Ives during visits there in the 1950s and settled in Cornwall in 1960, after ill-health had brought about his retire-ment from banking. O'Malley's early work – most of which was not seen until recently, as he had exhibited relatively little – is close at times to continental Expressionism, though also redolent of the Irish countryside and its past. In Cornwall he developed a stark elemental landscape style which, as had happened with Scott, almost inevitably led him into abstraction of a slightly mystical, often nature-based kind. He has since refined and subtilised his style fur-ther, and a series of visits he made to the Bahamas, largely for the sake of his health, brought into his work a new element of tropical

William Scott by F.E. McWilliam (1956). Two eminent Northern Irish artists.

imagery and colour. At his most characteristic, however, O'Malley is a brooding and inward-looking artist, in whom the Irish landscape and the Irish past, its myths and its whole psychic "aura", seem to come animistically to life. Certain critics, including myself, regard him as the finest Irish painter of his generation.

The leading Irish sculptor of his generation – the generation of the Living Art – was Oisin Kelly (1915-81), a versatile craftsman who was equally at home working in bronze, wood, stone or even steel. Deeply cultured, he drew on many sources ranging from Celtic art to the German Expressionist Barlach, and infused them with his own reticent, but firm, sensitive personality. He carried out some large-scale commissions (*The Fate of the Children of Lir* and *Chariot of Fire*, both in Dublin) and also worked a good deal for the Church; and in all that he did, he proved himself a dedicated, polished, highly adaptable craftsman. Yet though his public pieces are never less than well executed, his more original and personal work is on a smaller scale – his birds and animals in bronze, the *Dancing Sailor* in wood, the eloquent bronze head of the poet Austin Clarke. Superficially, Oisin Kelly was an eclectic, but his subtle, humorous, erudite mind forged his various stylistic borrowing and searching into so many links of a single chain, and the result, in some indefinable way, is always intensely Irish and Celtic.

The career of F.E. McWilliam (1909-92) was so closely tied to the English art movements of his time that his very real and conscious Irishness tended to be forgotten. He made his name among the Surrealists of the 1930s, but McWilliam was a varied, eclectic sculptor who absorbed many sources ranging from Moore and Hepworth to Indian erotic sculpture (he had been stationed in India during his service in the RAF). When one calls him an eclectic it is in the best sense, since he was a restless experimenter who mastered many materials, including wood, stone, bronze, even cement, and he never rested on what he had achieved before. The *Princess Macha* outside Altnagelvin Hospital in Derry is probably his best-known work, but his early Surreal period produced some genuine masterpieces, and the playful, erotic bronzes of his later

Irish Head by F.E. McWilliam (1949). McWilliam made his reputation in England and spent much of his life in London.

years include some of his finest pieces. As a Northerner, McWilliam reacted with horror and outrage to the Troubles in the 1970s, memorably expressed in his series of bronzes entitled *Women of Belfast*.

Melanie le Brocquy (born 1919), younger sister of Louis, has often been overlooked by Irish critics because of her rather small output and her small scale – many of her bronzes are virtual miniatures. The subtleties of her work are often apparent only to a trained eye, and for this reason she is something of a sculptor's sculptor. The life and career of Gerda Froemel (1932-75) were tragically cut short by drowning, perhaps the greatest loss Irish art has suffered in the last quarter-century. She was German by birth – or, more accurately, German-Czech – but most of her creative years were spent in Ireland and she thoroughly identified with it and blended effortlessly into its artistic life. Gerda Froemel worked in bronze, steel, stone and alabaster, and though she felt the imprint of artists as diverse as Giacometti, Brancusi and Lehmbruck, her style was her own and there is a sheer distinction of mind and a subtle, understated poetry in all her sculpture, as well as a rare degree of technical finish. Shallow, delicate modelling gives her sculptures a nuanced and pensive quality which is unique to her. While Oisin Kelly spoke almost always with an Irish accent, her sculptural language was more obviously continental European, and it deserves to be better known abroad. The same is largely true of Alexandra Wejchert (born Cracow, 1921), whose style has its roots in the Eastern and Central European tradition whose greatest master is Brancusi. Many of her sculptures are in metal or perspex and they combine formalist elegance and supple, rippling rhythms with a pronounced organic quality. In her twelve-feet-tall, two-piece steel *Freedom*, standing in an open space at the Allied Irish Bank's complex at Ballsbridge, Dublin, she has created probably the finest example of outdoor abstract sculpture in her adopted country. Imogen Stuart (born Berlin, 1927) is less purist and more versatile, working in a wide range of media – bronze, wood, stone – and often suiting the style itself to the needs of the commission in hand.

Some of her best work has been done for churches – she is a devout Catholic – but she is equally capable of creating outdoor figures for a supermarket. Her work draws on sources as different as Barlach, medieval carving, and Celtic art.

Surrealism never took deep roots in Ireland, though Colin Middleton went through a Surrealist phase and however one tries to classify the paintings of Patrick Hennessy (1915-80), it is apparent that he has a niche peculiarly his own. He might best be described as a Magic Realist, since he had a good deal in common with that European movement of the inter-war years, which was particularly strong in Amsterdam (Piet Koch and others). He used a polished technique so close to old-fashioned illusionism that at first glance it looks almost academic, but this became the vehicle for a kind of private theatre full of unspoken disquiet, tension and emotional oppression. Hennessy was also a stylish colourist, capable of passages of bravura painting when he chose, though his later work often descended into rather commonplace *trompe l'œil* effects. The Art Gallery in Limerick has one of his finest and most typical works, *Kinsale Harbour*, painted when Hennessy was living on the coast of his native County Cork.

At a time when portrait-painting had become largely the reserve of untalented academicians, Edward McGuire (1932 – 86), a portraitist of real distinction emerged. Superficially he has similarities with Lucian Freud, but his mentality was more refined and subtle than Freud's, more introverted and lacking Freud's outward panache. McGuire, an over-sensitive and mercurial personality much loved by his friends, was particularly successful in painting the Dublin intelligentsia, together with the poets Seamus Heaney (Ulster Museum, Belfast) and Michael Hartnett. In his closeness to Freud, he had been anticipated by Patrick Swift (1927-83), who had a remarkable success with his first exhibition with Victor Waddington while only twenty-five. Shortly after this he moved to London, where he became a figure in the now-legendary Soho bohemia of the time and edited, with the poet David Wright, the magazine *X*. During these London years he painted steadily but exhibited hardly

Freedom by Alexandra Wejchert (1985). This Polish-born sculptor works in an international Abstract style.

at all; then he moved to Portugal, where he worked on until his death, almost forgotten by the Dublin art world. A retrospective exhibition at the Irish Museum of Modern Art in 1993 was a revelation to a new generation, showing Swift's progression from his early, quasi-Freudian yet highly individual manner, through the striking portraits and cityscapes of his London years, to the light-flooded work of his final, Portuguese years.

Camille Souter, an artist of the same generation, is often reckoned to be Ireland's finest living woman painter, though she is English by birth (Northampton, 1929). Her pictures are usually small, tonally subtle and "painterly" in the best sense, though without obvious bravura – qualities which have led some admirers to compare her with Vuillard, no less. She has painted still life, landscape and a wide range of subject matter, always in her own intimate, quietly eloquent style. More recently, she has produced a series of pictures based on her experience as an amateur pilot. Patrick Scott (born 1921), a *rara avis* in Irish art, has upheld consistently the values of a quiet, tasteful, contemplative form of abstraction at a time when Action Painting seemed to be sweeping the boards, and Barrie Cooke (another naturalised English artist, born 1931) has shown himself to be an exceptional colourist, both in his lush landscapes and his many female nudes. Cooke is fascinated by Irish lakes and waterways (he is a dedicated fisherman), and this passion runs through his output, from the lyrical directness of his early pictures to the large, gestural, quasi-abstract work of recent years. The vision of Patrick Pye (born 1929) is occasionally close to that of Stanley Spencer, particularly in his religious paintings, but in his still lifes and more informal works he shows himself closer to the French tradition. And at a time when the North of Ireland painterly tradition seemed to be weakening, Basil Blackshaw (born 1932) has proved himself an independent figure of real calibre. The sculptor Carolyn Mulholland (born Lurgan, 1944) is equally independent of all trends and cliques, a factor which has not helped her reputation with the public, although she has carried out several large commissions. Her output encompasses a wide range, including

portraiture: one of her best achievements, is her bronze head of
Seamus Heaney.

Sean McSweeney (born Dublin, 1934) has painted many free,
lyrical landscapes of Wicklow and Sligo, where he lives, and has
shown that the Yeatsian tradition is still valid. He has also proved,
with a quiet consistency, that abstract Expressionist brushwork and
freedom can be combined entirely convincingly with a deep feel-
ing for regional colour and light. McSweeney, in fact, is one of a
number of artists (they include Brian Bourke, born in 1935) work-
ing quite independently of one another, and who have given a new
life to the generations-old tradition of painting the landscape and
seacoast of the West. A rather similar claim could be made for the
work of Nancy Wynne-Jones (born 1922), who is Welsh by birth
but spent her formative years as a painter in St Ives, where she
came into close contact with Peter Lanyon, but has lived and
worked in Ireland since the early 1970s. In her case, however, it
is the landscape of the Cork coastline and the Wicklow hills which
have drawn her, rather than the more fashionable West. She has
alternated between abstraction and relatively traditional landscape,
as well as painting many pictures in a refined, highly personal,
intimiste manner; her best works achieve a very individual balance
of the energetic, almost improvisational abstraction of the 1950s
with figurative subject matter. The Irish landscape, in fact, often
seems to naturalise overseas artists who settle in it, and to an extent
this has been the case with William Crozier (born 1930), who has
been an Irish citizen for many years but is a Glasgow Scot by birth
and training. Like so many Scottish artists, he was drawn early to
France; but less typically, he also felt the impact of German
Expressionism. Both have left their mark on his palette, which is
at once brilliant and intense; and he has brought this powerful
colour sense and grasp of abstract form to the landscape of West
Cork, in particular. Crozier is, in fact, an international figure,
represented in many collections besides those of the British Isles.

The case of Sean Scully, a younger man, is problematical, since
he was born in Dublin (in 1945) but moved to London as a child,

and as a painter has been largely identified with the New York School. Certainly his ties with Ireland, or with Irish art, appear to be tenuous, although he has exhibited in Dublin and from early in his career he had a strong Irish following. Scully's mature style to an extent takes off from the late work of Barnett Newman, which has proved so suggestive to a whole range of painters from Frank Stella to Minimalists. He has taken two stock devices of Modernism, the grid and the stripe, and has made them entirely his own. Both his colour sense and his formal subtlety have developed enormously in the past decade, and his exhibition at the Whitechapel Gallery in London in 1988 established him as a painter of international size. Hughie O'Donoghue (born Manchester, 1953) is even more problematical in this context, since he is of Irish ancestry but entirely English by upbringing and training. Yet his painting is curiously non-English – often very large in scale and format, and with a powerfully suggestive imagery which frequently seems to have its roots in nature and in myth. His recent series based on the theme of the crucifixion showed the breadth and intensity of his rhetoric, while another aspect of his work is seen in his large charcoal drawings – just as Scully's superb pastels act as a foil to the weighty, frontal, almost aggressive presence of his paintings.

Unlike the men and women of the Living Art, who were often consciously preoccupied with forging an Irish style in a contemporary idiom, the present generation of Irish painters and sculptors shows relatively little national feeling, in many cases none at all. The student unrest in the National College of Art in the late 1960s led to the ending of the conservative-minded, academic clique which had dominated it, and to their replacement by a new, Modernist-conscious staff and policy which have also produced a better level of technique than before. The RHA still exists, but it has lost much of its old power and prestige. The Living Art has tried spasmodically to recapture its old central role, but without much success, and has been in abeyance for several years now. The Oireachtas Exhibition, in theory the visual wing of the Irish

language revival, shows painters of all styles without obvious favouritism. Founded in 1960, Independent Artists supplied in the 1970s and 1980s a vehicle for all sorts of mavericks and outsiders, as well as for certain ambitious, rising young artists. Figurative Image, a group founded originally as a counterblast to the dominance of abstract art, staged a series of annual group exhibitions much respected in Dublin. Irish art, then, is highly eclectic and varied at the moment, and it is hard to single out any dominant trend. However, Dublin and Belfast remain off the beaten track internationally and this has led to many of the younger artists moving to Berlin, London, New York and other centres. A high proportion of these go less in search of stimulation than to find a living, since America, in particular, offers the prospect of well-paid teaching posts.

In 1967, a group of enthusiasts launched the Rosc exhibition, a four-yearly event which featured many international names and was a conscious attempt to put Ireland on the international exhibition circuit. Planned on a large scale which taxed the available spaces in Dublin, it varied in quality, but undoubtedly has helped to make the Irish public more art-conscious, besides gaining some much-needed prestige abroad. Some of the ground had already been broken by previous visiting exhibitions. For instance, in 1963 the Irish Exhibition of Living Art showed a cross-section of contemporary American art, and a year later the huge Johnson Wax collection caused great interest – not all of it friendly either – when it was mounted in the Dublin Municipal Gallery of Modern Art. A little later, the same gallery mounted a Francis Bacon exhibition which produced an equal degree of interest – and, almost inevitably, a rash of imitations. Whether it liked it or not, Dublin was being jerked into a new age; and the Rosc exhibitions were the climax to the process.

To single out names from the more recent wave, or waves, of artists would be invidious, since they come as densely (and sometimes as loudly) as Atlantic rollers on the West Coast. I might mention the leading trio of Irish New Expressionists, Michael

Mulcahy, Brian Maguire and Patrick Graham; the photo-realist Robert Ballagh; the innovative steel sculptor Conor Fallon, who got his start in St Ives but has closer affinities with such continental artists as Brancusi, Laurens and Gonzalez; the gifted Abstractionists Phelim Egan and Charles Tyrrell – but that is to ignore at least as many more. In Cork, a school of sculptors has emerged which includes the metal sculptors Eilis O'Connell and Vivienne Roche. The tax-free scheme for artists and writers introduced by Charles Haughey was an example of enlightened legislation which made the lot of the Irish artist easier. Outside Dublin, another vital factor has been the high level of activity in Cork, Limerick and other centres (Belfast, of course, is much closer to the art life of Britain). Today, you may find art galleries and art promotions in modest-sized towns where a generation ago art would have been considered either a luxury for the rich, or the self-indulgence of cranks and oddities. Another major event has been the recent conversion of the seventeenth-century Royal Hospital at Kilmainham, Dublin, into the Irish Museum of Modern Art (IMMA).

All this may not quite add up to a new renaissance, as some over-eager commentators claim, but it does add up to a very vital and varied Irish art world, full of self-confidence. It remains to be seen, however, whether the present epoch is one of reconciliation between the dominant American idioms and the more "native" ones, or whether Irish art will once again divide into hostile, or at least mutually exclusive groups. Or will sheer individualism and originality be the decisive factor, rather than the absorbtion of contemporary styles from overseas, however vital? The examples of Yeats, Swanzy, Hone and others suggest that much of the finest Irish art has been created by solitary visionaries rather than by schools or trends, however enlightened and consciously cosmopolitan these may be in outlook.

Now that Ireland is – both in theory and in practice – a full and active member of the EU it is tempting to think that her artistic links with London, Paris, Berlin, Madrid and Zurich will grow steadily closer and that artistic interchange will become as

Head of Joyce by Conor Fallon (1990). Working largely in steel, Conor Fallon has evolved a highly original style which stresses "open" volumes.

common in Dublin, Cork and Belfast as it is between the great European cities. So far, however, there is relatively little sign of this happening. Ireland continues to lie off the international gallery circuit, and Irish artists find it difficult – short of actually living abroad – to obtain a real, stable footing on the Continent. As for New York, a recent estimate put its artist population at 30,000, so Irish artists heading there are merely so many extra minnows or sprats in an already overcrowded pond – which, presumably, will not inhibit young and adventurous ones from trying their luck and talent there. Artistic emigration, therefore, seems likely to continue, with all the dispersal of energies and aims which it involves. No doubt, many artists today are migratory, and many of the leading figures maintain studios in different parts of the globe, but that can hardly serve as a model or pattern for the struggling majority. Ireland's internationalism, then, may be a loss and a gain; there may be greater interchange with other countries and cultures, but also an increasing loss of young and energetic people abroad – a familiar phenomenon.

Behind the current thirst after a rather ill-defined internationalism lies the uneasy feeling that Irish art of this century, with all its vitality and individualism, has lain largely outside the orbit of the great revolutionary movements in Paris and elsewhere. The exaggerated reputation of Mainie Jellett is part of the effort to atone for this, critically and intellectually, to build a pedigree for Irish Modernism and so bring it, by hook or crook, into the European mainstream. The same process can be seen at work in England, where certain alliances of critics and academics have been labouring busily to construct a scenario of Modernism – chiefly by over-praising the work of Wyndham Lewis, Bomberg and other pioneers from the First World War period. At heart, these people are probably as aware as anybody else that Modernism in Britain scarcely took any definite shape or coherence before the late 1920s and early 1930s with the emergence of Nicholson, Moore, Hepworth, Hitchens and a few other select figures; and even then it took on some of the ingrown, idiosyncratic quality common to much or

most British art in the last two centuries. To bring it into line with
the major continental movements requires a considerable exercise
in dialectics, if not even a degree of an out-and-out art-historical
distortion. Would it not be wiser, and also more honest, to allow
British art of this century its own continuity and line of develop-
ment, in conformity with its own traditions and temperament? The
Modern Movement in art, after all, was as varied as the Romantic
Movement of a century before and took in many cultural and
national traditions. To reduce it to a few strands is to narrow and
even distort it.

At least, in Nicholson and one or two more outstanding figures,
Britain did produce visual artists of genuine European quality and
size, whose Modernist and international credentials are impeccable.
Ireland, by contrast, can probably only point to Jack Yeats as an
artist of the very first rank; and although his stature is undoubted,
he is isolated in his time – as he realised perfectly well. The seismic
eruption of Cubism, the birth of abstract art, the revolution of pure
colour brought about by Fauvism and Expressionism, the ques-
tioning of our whole world of appearance and stock assumptions
by Surrealism and Dadaism – these have only touched Ireland in
a relatively tangential way. It is almost impossible to imagine a Naum
Gabo or an Alexander Calder emerging in Dublin. They could only
have happened in countries with an advanced technology and a
deep awareness of the extra dimensions which modern science
(using the term science in a metaphysical as much as a physical
sense) has added to our consciousness. Their training as engineers
shaped them both, and in their work art and science merge in a
new dynamism, which in turn gives birth to new forms. Both are,
in effect, sculptors of the Space Age and of an expanding mental
horizon.

The specifically twentieth-century energy, eruptive and almost
brutal, which pounds hypnotically through Stravinsky's *Rite of
Spring*, or convulses the whirling dancers in Matisse's *La Danse*, has
no real counterpart in Irish art either, even allowing for its smaller
and more local context. Perhaps such phenomena could only have

emerged in culturally seething capitals, as Paris was between 1880 and 1930, or New York from about 1945 to 1980 – cities in which the elité of many nations had congregated for a while, setting off mutual interactions like so many high-voltage wires. Yet Modernism was also felt in Russia, Italy, Germany and even in relatively provincial Spain, although in time both the Russian and Spanish Modernists mostly fled abroad. So why did it flourish so tardily in the British Isles? That is a question which would take an entire volume to answer, if it could be answered at all. What seems reasonably certain, in retrospect, is that Ireland's late introduction to Modernism was to a large extent the result of its reliance on Britain, which stands immovably between it and the Continent. Not even the traditional links with France could bridge such a gap or time-lag; and figures such as Mainie Jellett arguably came rather too late and, in any case, possessed adaptable talents rather than indisputable, transforming genius.

Allowing for the enormous speed and immediacy of modern communications, will art centres and art capitals in this sense cease to be necessary or, at least, become less necessary than they were? Will art activity no longer concentrate itself into a few key areas and big-city centres, but instead spread itself gradually and work mainly as a diffused energy which permeates all areas of Europe? In that case, it will be a force which flows through the limbs and extremities of Europe, instead of being confined to the head and brain. And it may be in such a context that the future of Irish art will lie, rather than as a poor relation on the outer Atlantic rim of Europe.

Acknowledgements

The publisher would like to thank the following for permission to reproduce paintings and photographs:

National Gallery of Ireland for: *The Rye Water near Leixlip* by William Davis; *George Moore, Maud Gonne MacBride* and *Portrait of Isaac Butt* by John B Yeats; *Thomas Moore* by Martin Shee; *The Marriage of Princess Aoife and the Earl of Pembroke (Strongbow)* by Daniel Maclise; *Opening of the Sixth Seal* by Francis Danby; *The Poachers* by James Arthur O'Connor; *In the Phoenix Park; Light and Shade* and *John Hughes, Sculptor* by Walter Osborne; *Shades of Evening* by Mildred Anne Butler; *Doctor's Visit* by Leo Whelan; *Landscape near Castle Townshend* by Egerton Bushe Coghill; *Hellelil and Hilebrand/Meeting on the Turret Stairs* (detail) by Sir William Frederick Burton; *Before the Start, The Wake House* and *The Pirate* by Jack B Yeats; *Reclining Nude* by Roderic O'Conor; *Old Convent Gate, Dinan* by Joseph Kavanagh; *A Girl Reading* by Patrick MacDowell; *Sir Hugh Lane* by Sarah Harrison; *Le Petit Dejeuner* by Sarah Purser; *Moore Street Market, Dublin* by Michael Healy; *Man on a Telegraph Pole* by Paul Henry; *Bathers Surprised* by William Mulready; *Fishing Boat on the Beach at Scheveningen* and *A Vine Pergola* by Nathaniel Hone the Younger; *Looking Out to Sea* and *Oliver Sheppard* by William Orpen.

Hugh Lane Municipal Gallery of Modern Art, Dublin for: *Evening Malahide Sands* by Nathaniel Hone; *Ireland 111* by Patrick Graham; *Waiting to go on the Canal* by Camille Souter; *Midsummer Window with Moths* by Tony O'Malley; *Cats in the Kitchen* by Nano Reid; *The Eve of St Agnes* by Harry Clarke; *There is No Night* by Jack B Yeats; *Towards Night and Winter* by Frank O'Meara; *The Foundation*

Blue Grid by Sean Scully courtesy of Waddington Galleries, London.

Bend in the Road courtesy of Nancy Wynne-Jones.

Head of Joyce courtesy of Conor Fallon.

The Crawford Municipal Art Gallery, Cork for: *Kitchen Window* by Leo Whelan; *An Strachaire Fir* by Joseph Higgins; *Jack Butler Yeats* by James Sleator.

Trinity College for: *Edmund Burke* and *Oliver Goldsmith* by John Foley.

The Board of Trustees of the National Museums and Galleries on Merseyside for: *The Death of Nelson* by Daniel Maclise; *Off to the Fishing Ground* by Stanhope Forbes.

The author would like to thank Dr. Michael Wynne of the National Gallery of Ireland for his comments on the text.

Bibliography

General

Arnold, Bruce, *A Concise History of Irish Art*, Thames and Hudson, 1968.

Barrett, Cyril, *Irish Art in the Nineteenth Century*, (exhibition catalogue) Crawford Municipal Gallery, Cork, 1972.

Bodkin, Thomas, *Four Irish Painters*, Irish Academic Press, 1987.
 Hugh Lane and his Pictures, Stationery Office/Arts Council of the Irish Republic, 1956.

Briggs, Asa (ed.), *The Nineteenth Century*, Thames and Hudson, 1970.

Campbell, Julian, *The Impressionists; Irish Artists in France and Belgium 1850-1914*, National Gallery of Ireland, Dublin, 1984.

Craig, Maurice, *The Architecture of Ireland; from earliest times to 1880*, Batsford, London/Easons, Dublin, 1982.

Crookshank, Anne and Glin, Knight of, *The Painters of Ireland c. 1660-1920*, Barrie and Jenkins, London, 1978.

Dawe, Gerald, *Faces in a Bookshop; Irish Literary Portraits* (introduction), Kennys, Galway, 1990.

Dunne, Aidan, *Irish Art; the European Dimension*, RHA Gallery, Dublin, 1990.

Fallon, Brian, *Contemporary Artists from Ireland* (exhibition catalogue), Austin/Desmond Fine Art, London, 1990.

Fox, Caroline and Greenacre, Francis, *Artists of the Newlyn School (1880-1900)*, Newlyn Orion Galleries, Cornwall, 1979.

Harbison, Peter, Potterton, Homan and Sheehy, Jeanne, *Irish Art and Architecture; from Prehistory to the Present*, Thames and Hudson, London, 1978.

Hewitt, John and Catto, Mike, *Art in Ulster*, 2 vols., Blackstaff Press, Belfast, 1991.

Kennedy, Brian, *Irish Painting*, Town House, Dublin, 1993.

Kennedy, S.B., *Irish Art and Modernism, 1880-1950*, Institute of Irish Studies, Queen's University, Belfast, 1991.

Keogh, Dermot, *Twentieth Century Ireland; Nation and State*, Gill and Macmillan, Dublin, 1994.

Klingender, Francis, *Art and the Industrial Revolution*, Paladin Books, London, 1972.

Knowles, Roderick, *Contemporary Irish Art*, Wolfhound Press, Dublin, 1982.

McConkey, Kenneth, *A Free Spirit; Irish Art 1860-1960*, Antique Collector's Club/Pyms Gallery, London, 1990.

Maas, Jeremy, *Victorian Painters*, Barrie and Jenkins, London, 1988.

Moore, George, *Hail and Farewell*, Colin Smythe/ Catholic University of America Press, 1985.

Paley, Morton D., *The Apocalyptic Sublime*, University Press, 1986.

Pyle, Hilary, *Irish Art 1900-1950* (exhibition catalogue), Crawford Municipal Gallery, Cork, 1976.

Redgrave, Samuel and Richard, *A Century of Painters of the English School*, Phaidon Press, 1980.

Sheehy, Jeanne, *The Rediscovery of Ireland's Past; the Celtic Revival 1830-1930*, Thames and Hudson, London, 1980.

Stalley, R.A., *Architecture and Sculpture in Ireland 1150-1350*, Gill and Macmillan, Dublin, 1971.

Strickland, W.G., *A Dictionary of Irish Artists*, 2 vols., Irish University Press, 1969.

Sutton, Denys (ed.), *Aspects of Irish Art* (exhibition catalogue), National Gallery of Ireland, 1974.

Talmon, J.L., *Romanticism and Revolt; Europe 1815-1848*, Thames and Hudson, London, 1967.

Wood, Christopher, *The Dictionary of Victorian Painters*, Antique Collector's Club, London, 1987.

Wynne, Michael, *Irish Stained Windows*, Easons, Dublin, 1977.

Monographs

Adams, Eric, *Francis Danby*, Yale University Press, 1973.

Alley, Ronald and Flanaghan, T.P., *William Scott*, Arts Councils of Northern Ireland and the Republic, 1986.

Arnold, Bruce, *Mainie Jellet and the Modern Movement in Ireland*, Yale University Press, 1991.
 Orpen, Lives of Irish Artists series, Town House/National Gallery of Ireland, 1991.
 Orpen; Mirror to an Age, Routledge and Kegan Paul, London, 1981.

Benington, Jonathan, *Roderic O'Conor*, Irish Academic Press, Dublin, 1992.

Bowness, Alan, *William Scott*, Tate Gallery, London, 1972.

Campbell, Julian, *Mary Swanzy 1882-1978*, Pyms Gallery, London, 1986.
 Nathaniel Hone the Younger 1831-1917, National Gallery of Ireland, 1991.

Carty, Ciaran, *Robert Ballagh*, Magill, Dublin, 1986.

Cronin, Anthony, *Dead as Doornails*, Poolbeg Press, Dublin, 1980.

Crookshank, Anne, *Butler*, Lives of Irish Artists series, Town House/National Gallery of Ireland, 1991.
 Camille Souter (exhibition catalogue), Douglas Hyde Gallery, Dublin, 1980.

Deane, John F. (ed.), *Towards Harmony; a Celebration for Tony O'Malley on his Eightieth Birthday*, Dedalus Press, Dublin, 1993.

Denson, Alan, *An Irish Artist; W. J. Leech 1881-1968*, Kendal, Northumberland, 1969.

De Vere White, Terence, *A Fretful Midge*, Routledge and Kegan Paul, London, 1957.

Dunne, Aidan, *Barrie Cooke*, Douglas Hyde Gallery, Dublin, 1986.

Fallon, Brian, *Edward McGuire*, Irish Academic Press, Dublin, 1991.
 Tony O'Malley; Painter in Exile, Arts Council of the Republic, Dublin, 1983.

Ferran, Denise, *Leech*, Lives of Irish Artists series, Town House/National Gallery of Ireland, 1991.

Gooding, Mel, *F.E. McWilliam; Sculpture 1932-89*, Tate Gallery, London, 1989.

Gordon Bowe, Nicola, *Harry Clarke; his Graphic Art*, Dolmen Press, Portlaoise, 1983.
> *The Life and Work of Harry Clarke*, Irish Academic Press, Dublin, 1989.

Gowrie Grey, *Derek Hill; An Appreciation*, Quartet Books, London, 1987.

Henry, Paul, *An Irish Portrait*, London, 1940.
> *Further Reminiscences*, ed. Michael Longley, Belfast 1976.

Hutchinson, John, *James Arthur O'Connor*, National Gallery of Ireland, 1985.

Johnston, Roy, *Roderic O'Conor*, Barbican Art Gallery, London/Ulster Museum, Belfast, 1985.

Kennedy, Brian P. (ed.), *Art is My Life; a Tribute to James White*, National Gallery of Ireland, Dublin, 1991.
> *Yeats*, Lives of Irish Artists series, Town House/National Gallery of Ireland, 1991.

Kennedy, S.B., *Henry*, Lives of Irish Artists series, Town House/National Gallery of Ireland, 1991.

Kinsella, Thomas (trans.) and Le Brocquy, Louis (illus.), *The Tain*, Dolmen Press, Dublin, 1969.

Le Harviel, Adrian, *Hone*, Lives of Irish Artists series, Town House/National Gallery of Ireland, 1991.

Lavery, Sir John, *The Life of a Painter*, London, 1940.

McConkey, Kenneth, *Sir John Lavery*, Cannongate Press, Edinburgh, 1993.

Marle, Judy and Flanagan, T.P., *F.E. McWilliam*, Arts Councils of Northern Ireland and the Republic.

Moore Heleniak, Kathryn, *William Mulready*, Yale University Press, London, 1980.

Murphy, Paula, *O'Conor*, Lives of Irish Artists series, Town House/National Gallery of Ireland, 1991.

Murphy, Seamus, *Stone Mad*, Routledge and Kegan Paul, London, 1966.

Murphy, William M., *Prodigal Father; the Life of John Butler Yeats 1839-1922*, Cornell University Press, Ithaca and London, 1978.

Murray, Peter, *William Crozier; Paintings 1949-1990* (exhibition catalogue), Crawford Municipal Art Gallery, Cork, 1990.

O'Meara, Veronica Jane (ed.), *PS...Of Course; Patrick Swift 1927-1983*, Gandon Books, Dublin, 1993.

Orpen, William, *Stories of Old Ireland and Myself*, London, 1924.

Potterton, Homan, *Andrew O'Connor*, Trinity College, Dublin, 1974.

Pyle, Hilary, *Jack B. Yeats; a Biography*, Rouledge and Kegan Paul, London, 1970.
 Jack B. Yeats; a Catalogue Raisonée of the Oil Paintings, 3 vols., Andre Deutsch, London, 1992.

Ruane, Frances, *Patrick Collins*, Arts Council of the Republic, Dublin, 1982.
 The Delighted Eye (exhibition catalogue), Roundhouse, London, 1980.

Sheehy, Jeanne, *Osborne*, Lives of Irish Artists series, Town House/ National Gallery of Ireland, 1991.
 Walter Osborne, National Gallery of Ireland, 1983.

Turpin, John and Ormond, Richard, *Daniel Maclise 1806-1870* (exhibition catalogue), Arts Council of Great Britain, 1972.

Walker, Dorothy, *Louis le Brocquy*, Ward River Press, Dublin, 1981.
 The Work of Oisin Kelly, Sculptor (exhibition catalogue), Arts Councils of Northern Ireland and the Republic, 1978.

White, James, *Gerard Dillon; an Illustrated Biography*, Wolfhound Press, Dublin, 1994.
 John Butler Yeats and the Irish Renaissance, Dolmen Press, Dublin, 1972.

Index